APERTURE

Photographs by Nancy Ackerman,
Walter Bigbee, Ken Blackbird, Ron Carraher,
Pamela Shields Carroll, Joseph Concha,
Jesse Cooday, Patricia Deadman, Monica
Godoy, John C. H. Grabill, Jeremy Huesers,
Zig Jackson, April Jiron, Rose Jones,
Ronald Lewis, Jr., Carm Little Turtle,
George Longfish, James Luna, Lee Marmon,
Larry McNeil, David Neel, Bethany Nez,
Horace Poolaw, Winnie Poolaw, Jolene
Rickard, Monty Roessel, Leslie Marmon Silko,
Greg Staats, John Stands, Maggie Steber,
Jeffrey M. Thomas, Hulleah Tsinhnahjinnie,
Schyle Vaughn, Richard Ray Whitman.

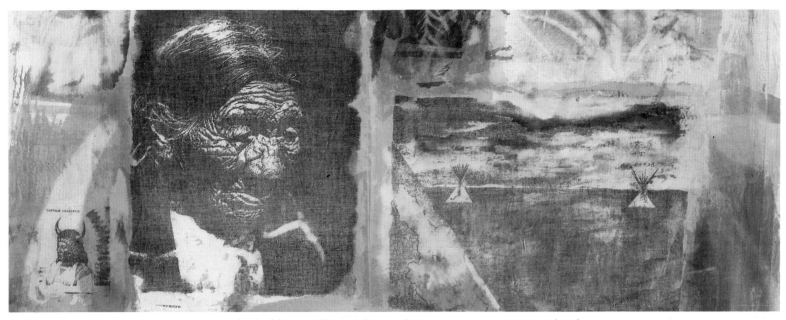

Pamela Shields Carroll (Blackfoot), *Ghost Dance Remnant*, 1990, detail

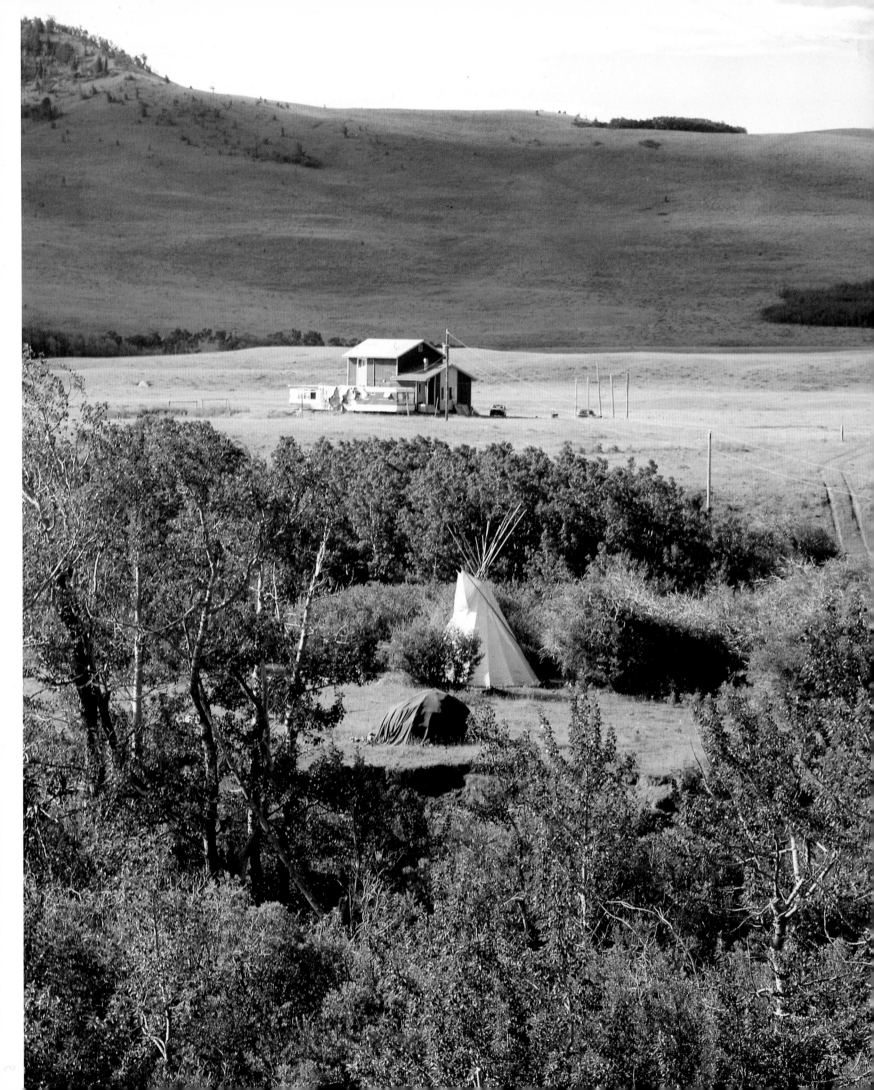

STRONG HEARTS:
NATIVE AMERICAN VISIONS AND VOICES

Why do certain photographs have the power to express something vital—something unforgettable—about individuals, places, or events depicted, whereas others seem devoid of life? This problem is perhaps most obvious in images of indigenous people, in which the encounter between photographer and subject is inevitably filtered through cultural differences—and misconceptions born of those differences.

In the pages that follow, Native American Indian photographers and writers image a world that, until recently, has been pictured largely by white people. During the nineteenth century, ethnologists and studio photographers documented Indian communities that survived the takeover of tribal territories. Later, around the turn of the century, Pictorialists created romanticized images of chiefs and warriors—images that fit then-current and still-prevalent beliefs that indigenous people are exotic species doomed to extinction. More recently, filmmakers have often recast history for the demands of scripts and shooting locations. But rarely have Native self-perceptions been allowed to participate in the popular vision of American Indians.

For *Strong Hearts*, Aperture invited contemporary American Indian photographers throughout the United States and Canada to contribute work, hoping to generate a lively debate on photography's contribution to perceptions of Native cultures. The scope and diversity of their photographs—from intimate family portraits to expressionistic images of darkly emotional power—present a world apart from what most people imagine when they hear the words "Native American photography."

From Lee Marmon, whose black-and-white image of a Laguna, New Mexico, neighbor minding his sheep shimmers with crystalline desert light; to Maggie Steber, whose color series "An American Family" captures the patterns of everyday life in Anadarko, Oklahoma; to Zig Jackson, who satirizes white tourists becoming anthropological subjects as they photograph Native American powwow dancers—this volume offers an inside view of Indian country.

The images here provided a springboard for three distinguished American Indian writers on photography and culture: Paul Chaat Smith, Theresa Harlan, and Jolene Rickard. Verbal imagery by four leading Native American poets—Leslie Marmon Silko, Luci Tapahonso, James Welch, and Linda Hogan—bring storytelling traditions to life, demonstrating the powerful connection contemporary Native American art and literature maintain with oral histories.

Ken Blackbird (Assiniboine), *House, Tepee, and Sweatlodge*, 1990

With mordant humor, essayist and critic Paul Chaat Smith shows that, even today, perceptions of Native people have not changed much at all. Comparing the use of firearms against Indians with that of the camera, he shows that most of what we know about Native Americans has been shaped by photography and film. Smith writes, "If one machine [the repeating pistol] nearly wiped us out . . . another gave us immortality. . . . Without movies, the Comanches would be an obscure chapter in Texas history. With them, we live forever." Smith demands a clear-eyed-view, one that cuts through the "confusion and ambivalence, the amnesia and wistful romanticism" that have identified American Indians in ways that have suited the changing social and political moods of the last one hundred and fifty years.

"Creating a visual history," says curator Theresa Harlan, "is a question of ownership. . . . Before too many assumptions are made, we must define history, whose history, and created by whom." Harlan goes on to deconstruct images dense with visual metaphor, which may be difficult for non-Native viewers. She writes, "The practice of visual memories and representations is a conflicted process. As historic objects and representations reveal how people knew themselves and their relationship to their world, contemporary image making and representations reveal, on some levels, how little we know about ourselves."

Photographer and educator Jolene Rickard likens assertions of cultural independence and sovereignty by Native people to a line drawn in the sand at the ocean's edge. She points out that even in art-world circles, where questions of identity are powerful currency, indigenous photographers must constantly overcome definitions of "the white man's Indian." Those images, she says, "are the documentation of our sovereignty. Some stick close to the spiritual centers, while others break ideological rank and head West. The images are all connected, circling in ever-sprawling spirals the terms of our experience as human beings. The line drawn in the sand . . . has always been a taunt—an ancient lure hooking memories through time—shifting the way we see our lives. Photographs are just the latest lure."

These images and texts hold compelling truths about personal identity, race, politics, family, and society. More than artistic expressions, they are pictures of life. We are deeply indebted to the photographers and writers whose dedication and generosity have made this project possible. *Strong Hearts: Native American Visions and Voices* aims to stimulate real cultural exchange for a long time to come—and to convey the experiences and insights of Native artists defining their own cultures today. —THE EDITORS

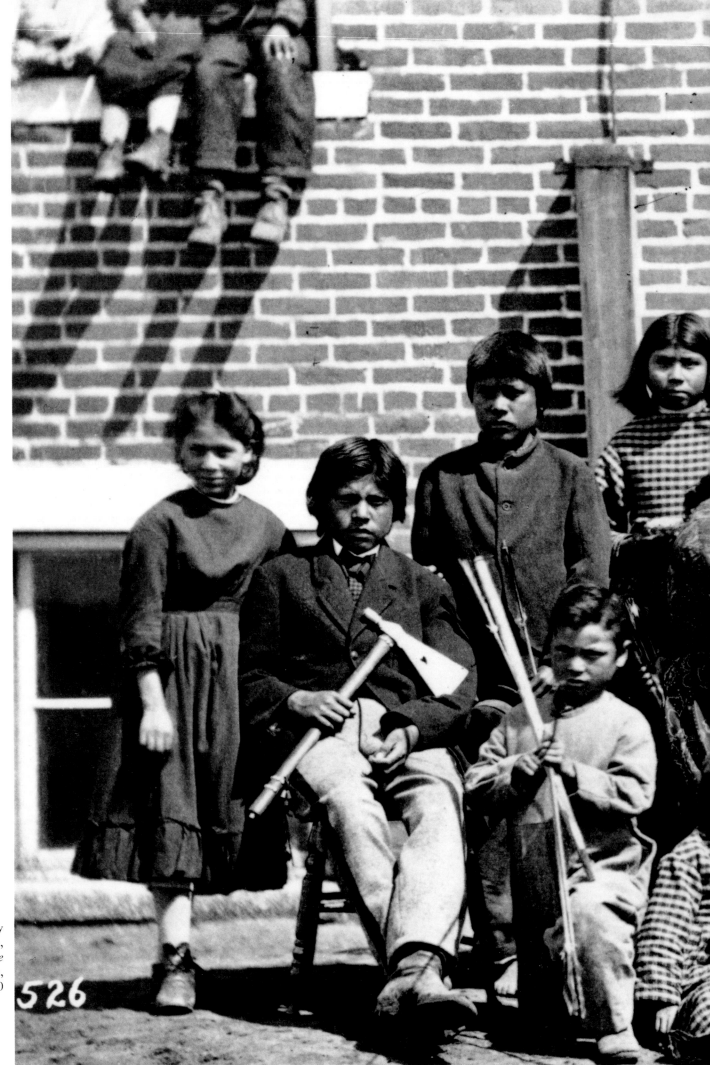

William Henry
Jackson,
*Pawnee
Schoolchildren*,
ca. 1890

526

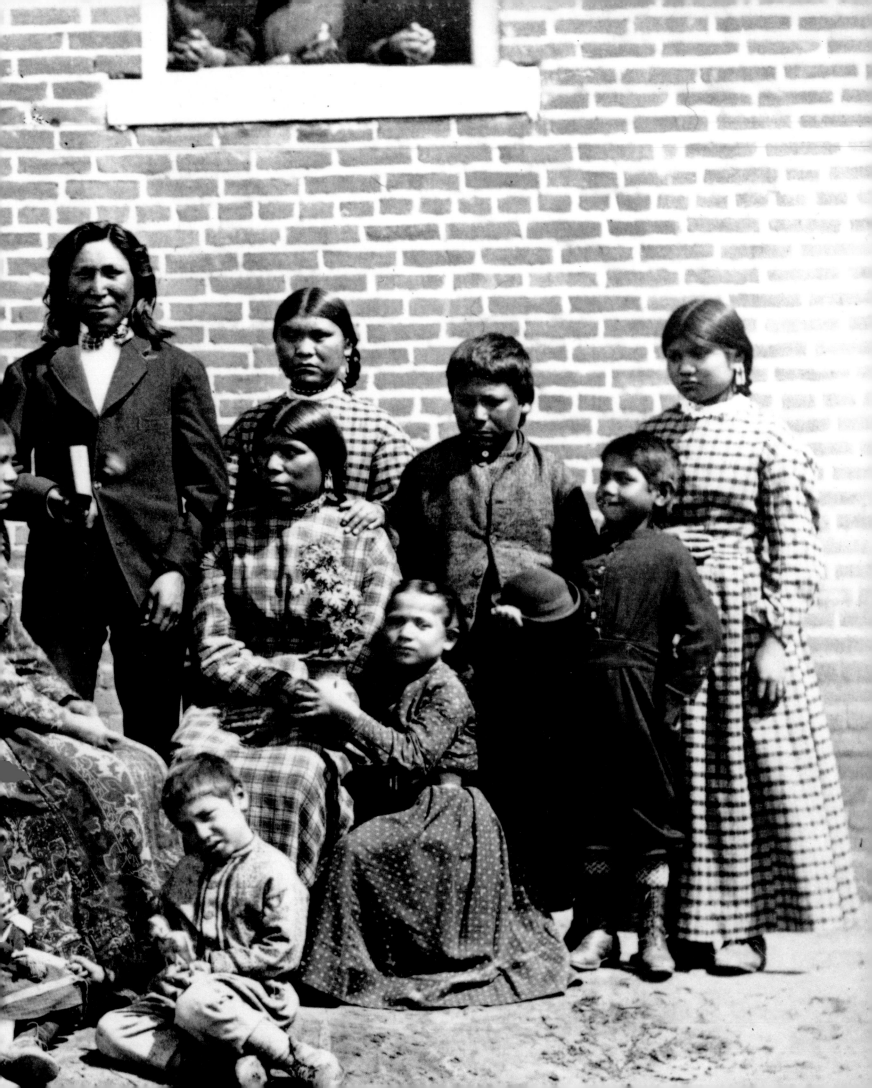

GHOST IN THE MACHINE

BY PAUL CHAAT SMITH

They called my great-uncle Cavayo "Name Giver." He was the one who decided what to call the marvelous toys and dazzling inventions modern times brought to the Comanche in the last half of the nineteenth century.

He looks out at me from a framed picture taken at Fort Sill, Oklahoma, in November of 1907. Cavayo and three dozen other well-known Kiowas, Apaches, and Comanches are arranged in the style of a high-school class picture. Some wear ties, some wear bandannas, and most have braids. Each is numbered and then identified on the photograph: Maximum Leader Quanah Parker ("Chief of the Comanches") is number 1. Cavayo ("Headman of the Comanches") is number 5. In 1907 he was nearly seventy, and he sits a few spaces to the left of Quanah, hat in hand, with long silver hair and a trace of amusement on his face.

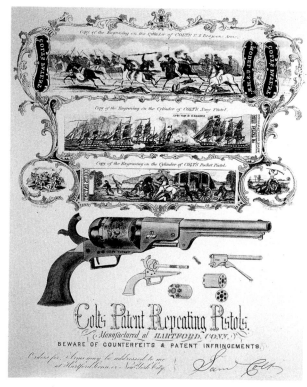

Advertisement for Colt .44 revolver, ca. 1850

In order to give something an appropriate name you must first understand it. Cavayo, to be charged with this responsibility, must have had a particularly sharp eye for technology. Over the decades he would have seen the new and improved models of guns and beads and cameras, and had to decide when those improvements justified a new name. By all accounts, Comanches were, and are, among the most practical tribes, with just a few taboos, and nearly all of those could be waived in an emergency. It seems doubtful Cavayo would have fallen for that line about cameras as soul-catchers. They were too busy trying to figure out new ways to obtain the latest firearms.

On good days, my ancestors were some of the finest people you would ever want to meet, generous and friendly and fun to be around, especially at parties. But we also were world-class barbarians, a people who for a hundred and fifty years really did all that murdering and kidnapping and raping and burning and looting, against Mexicans, Apaches, Utes, Pawnees, Pueblos, Americans, Poncas, Tonkawas—well, yes, pretty much anyone in our time zone. Compared to us, the Sioux were a bunch of Girl Scouts.

As a life-style it wasn't for everyone, but as a group we liked it. Others objected. The first guns that showed up were a joke, and even though we traded for them and appreciated their usefulness in certain situations, real men preferred repeating arrows—two straight black grooves on one side, two red spiral grooves on the other side—instead of nonrepeating, unreliable, noisy, and, frankly, rather unattractive guns.

This would soon change, however. An arms race began that we were destined to lose. In 1840, with the war against us going badly, a visionary Texas Ranger named Sam Walker made an extraordinary journey. Walker knew that only with a vastly improved firearm could his Rangers prove successful, so he traveled to the Colt factory in Paterson, New Jersey, and worked with the great Colt himself to perfect the world's first repeating pistol. It was called the "Walker Colt" caliber .44 revolver. The gun that revolutionized Indian-fighting, and weaponry in general, was a machine designed for one purpose: to kill Comanches. To make this very clear, each pistol carried an engraving of a battle between Comanches and Texas Rangers. We frantically tried to acquire the new guns but had limited success—imagine a member of the Crips trying to buy a dozen Stinger rocket-launchers

in the midst of the 1992 riots in L.A: not impossible but really, really difficult.

There should have been a special camera invented to shoot Indians as well, given the tremendous influence photography has had on us. If one machine nearly wiped us out—we numbered just over a thousand when my grandparents were born at the turn of the century—another gave us immortality. From the first days of still photography, anthropologists and artists found us a subject of endless fascination. When the pictures began to move, and then talk, they liked us even more. We starred in scores of movies. John Wayne's Westerns always seemed to take place in Texas or some other part of Comancheria. In *The Searchers*, Wayne spends years trying to find a girl we abducted. He succeeds, but by then she's gone "Comanch," and he must decide whether to kill her or not. The Duke identified so strongly with this movie that he named his son Ethan, after the fictional character he played.

The movies gave us international fame. Without them, the Comanches would be an obscure chapter in Texas history books. With them, we live forever.

In the age of moving images, we remain a favorite target of still photographers. The pictures in recent Indian coffee-table books, the ones that always seem to feature *Elder* and *Spiritual* in their titles, are a bit of deceptive flattery. The clear, unstated message of these books is this: the vast majority of Indians—there is no nice way to say it—disappoint. We have, apparently, lost our language, misplaced our culture. We rarely make rain anymore or transform ourselves into cougars and magpies. We use glass beads and disposable cigarette lighters and sometimes, when no one is looking, even throw trash out of our pickups. We are not worthy enough to be members of the coffee-table book tribe.

To me, those books and the photographers behind them are like big-game hunters on safari, and their big game is the real Indian. They set out from Berkeley or New York or Phoenix in their Range Rovers or Grand Cherokees, armed with Leicas and Nikons and Zeiss lenses, trained observers who see nothing. They barely glance at the fourteen-year-old boy in baggy pants and the Chicago Bulls sweatshirt as he screams down the road in his Kawasaki dirtbike, too fast and no helmet either. They ignore the fat guy with the Marine haircut and bad skin who pumps their gas at the Sinclair station. Busy checking directions provided by a German anthropologist, they miss the pack of excited young women in designer jeans and damaged hair, trading gossip on their way to a friend's house where the satellite dish actually works for an evening of *Melrose Place* and microwaved popcorn. If our visitors cared to stop for dinner, the basketball coach who lives alone in the trailer just past the power station I am sure would invite them in and share his chili and fry bread from the night before; his only plans for the evening are the Maple Leafs' and catching up on the latest controversies in deconstructionist theory with the new issue of *Third Text* that just arrived from London.

I am afraid that we present a rather pathetic tableau to the Big Game Photographers. I imagine they feel sorry for the Indians they encounter on their way to an audience with their quarry, the Perfect Master. *Drunks stumbling in the road, reason is those broken treaties, cycle of poverty, stupid Bureau of Indian Affairs, whole gambling thing, I don't know about that . . .* and when they find his house in the middle of nowhere (the directions might as well have been in German) all their hard work pays off. The Perfect Master delivers, with astonishing tales and authentic wrinkles, and the equipment, thank God, works without a hitch and the P.M., what a guy, even takes our picture with his little automatic 35mm and seemed fine with the money (five crisp new twenties in a discreet white envelope), didn't even count it and *wait until they see these prints in New York.* They dream of book deals and cable-television infomercials.

They blow right past us, without a clue.

Perhaps the niece who likes bad television spends Tuesday nights teaching the Cheyenne she learned from her grandparents to her friends. Maybe the postmodern basketball coach finally sees his critique of Foucault published in Belgium. (Unfortunately for him, there is not one person on the entire Crow reservation who reads Flemish.) I am pretty sure the truculent grandson finally agrees to wear his new helmet. And the overweight employee of the Sinclair station—I'm just guessing here—spearheads a grassroots campaign that sends the crooked tribal chairwoman and all of her cronies packing.

I do not know how their stories end, but I know the possibilities are there for the unexpected, the surprising, the improbable, and even the impossible. And these possibilities are precisely what escape the big-game hunters. They search for ghosts, for elders trapped in amber. Sometimes they even find them. But no matter what they find, they miss far more.

The photographers in these pages, on the other hand, don't miss much. Their images show us our families, at their Sunday afternoon best and predawn, post-bar-closing worst. We see our grandparents, foolish in parade cars and ridiculous in war bonnets, laughing in a way you never see them laugh in most pictures taken by non-Indians. Like my bloodthirsty progenitors, these photographers evidence a fine appreciation for technology and all it can accomplish. They are fearless in other ways, and not just in technical proficiency. They dare to experiment, to theorize, to argue and harangue, to tease and joke. They are not following anyone's instructions. To use the parlance of the late nineteenth century, these Indians have "strayed off the reservation."

For a genre still new, there is a remarkable amount of conceptual work being done. But that should not surprise us either. Exploration of the cutting-edge theoretical issues that photography presents is one of our traditions. Each of us has a complex relationship with photography, and each knows it. That relationship is one of culture, of history, of politics. It is immediate and concrete, and at the same time wrapped up in the kind of intricate theoretical issues that can give you a headache in five minutes flat. It is Sitting Bull pushing his signed photographs in Europe in the last century, and Leonard Crow Dog inviting film crews to shoot the Sun Dance in this one. It's looking for—and finding—old pictures of your rela-

tives at the Smithsonian's National Anthropological Archives. It is our radical leaders from the 1970s finding steady movie work in the 1990s, and the haunting thought that comes at you like a freight train from hell that no pictures exist of Crazy Horse, but the U.S. Postal Service issued a commemorative postage stamp of him anyway. It is our own frequent willingness to lead the searchers in their quest for the real Indian. It is the terrible truth that most of us, in dark, painful moments, have felt inadequate for not living up to the romantic images. We know they aren't really true, of course. We are somehow supposed to be immune from their powerful beauty, yet the reality is that we are particularly vulnerable.

We approach the millennium as a people leading often fantastic and surreal lives. The Pequot, a tribe all but extinct, run the most profitable casino in the country, and tribe members are becoming millionaires. But guess who's still the poorest group in North America? Vision-quest retreats and sweat-lodge vacations are offered in the pages of *Mother Jones*, and one of our so-called best friends in the entertainment industry bankrolls fawning documentaries on us but refuses to rename the Atlanta Braves, and that *Dances With Wolves*—I'm warning you don't get me started—NOT JUST THE NOVEL BUT EVEN THE SHOOTING SCRIPT SAID IT WAS ABOUT COMANCHES AND THEY ONLY CHANGED IT BECAUSE THE PRODUCTION MANAGER COULDN'T FIND ENOUGH BUF-FALOES IN OKLAHOMA AND THEY MADE THE COMANCHES SIOUX JUST LIKE THAT—POOF—AND EVERYONE IN MY FAMILY LIKED IT ANYWAY!!!!

The brilliant Palestinian intellectual and troublemaker Edward Said, author of *Orientalism*, wrote that "in the end, the past possesses us." Okay, Eddie, I get it. But is it suppose to possess us *this much*? The country can't make up its mind. One decade we're invisible, another dangerous. Obsolete and quaint, a rather boring people suitable for schoolkids and family vacations, then suddenly we're cool and mysterious. Once considered so primitive that our status as fully human was a subject of scientific debate, some now regard us as keepers of planetary secrets and the only salvation for a world bent on destroying itself.

Heck, we're just plain folks, but no one wants to hear that.

But how could it be any different? The confusion and ambivalence, the amnesia and wistful romanticism make perfect sense. We are shape-shifters in the national consciousness, accidental survivors, unwanted reminders of disagreeable events. Indians have to be explained and accounted for, and somehow fit into the creation myth of the most powerful, benevolent nation ever, the last best hope of man on earth.

We're trapped in history. No escape. Great-uncle Cavayo must have faced many situations this desperate, probably in godforsaken desert canyons against murderous Apaches and Texans. Somehow, I know what he would say: Get the best piece you can find and shoot your way out.

I think the photographers in this book are doing exactly that.

John C. H. Grabill, *Villa of Brule*, Deadwood, Dakota, ca. 1891

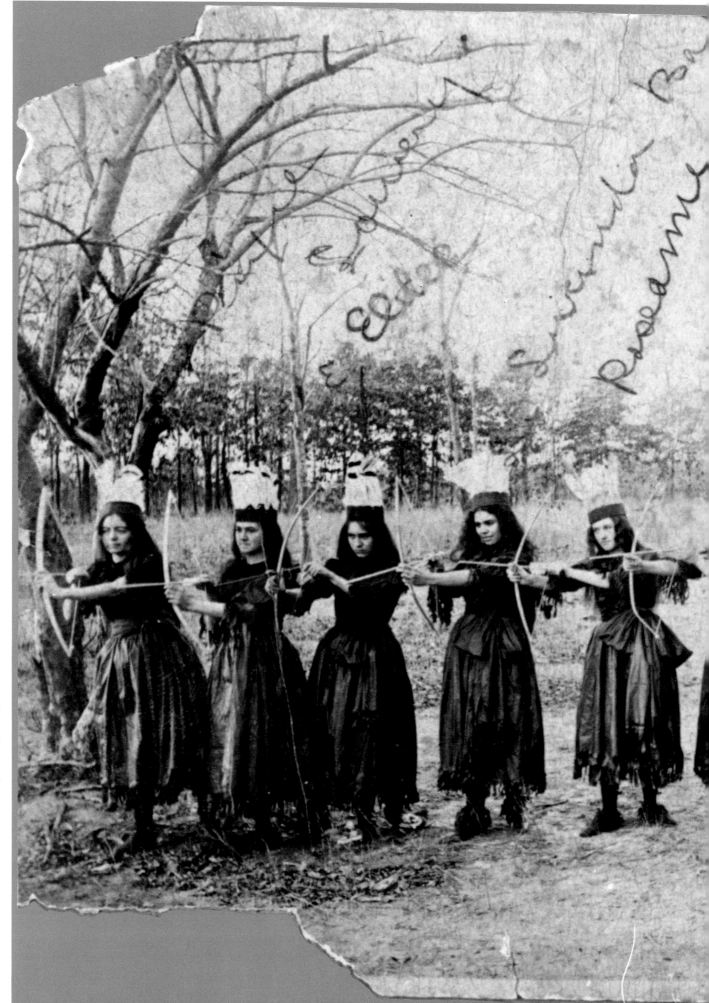

Cherokee Female Seminary Students, Tahlequah, Oklahoma ca. 1881, photographer unknown, Left to right: Pixie Maynes, Lowery, Eldee Starr, Lucinda Ballard, Roseanne, Jan Ross, Alice French, Mayme Starr, Jennie Foreman, Trim Morris

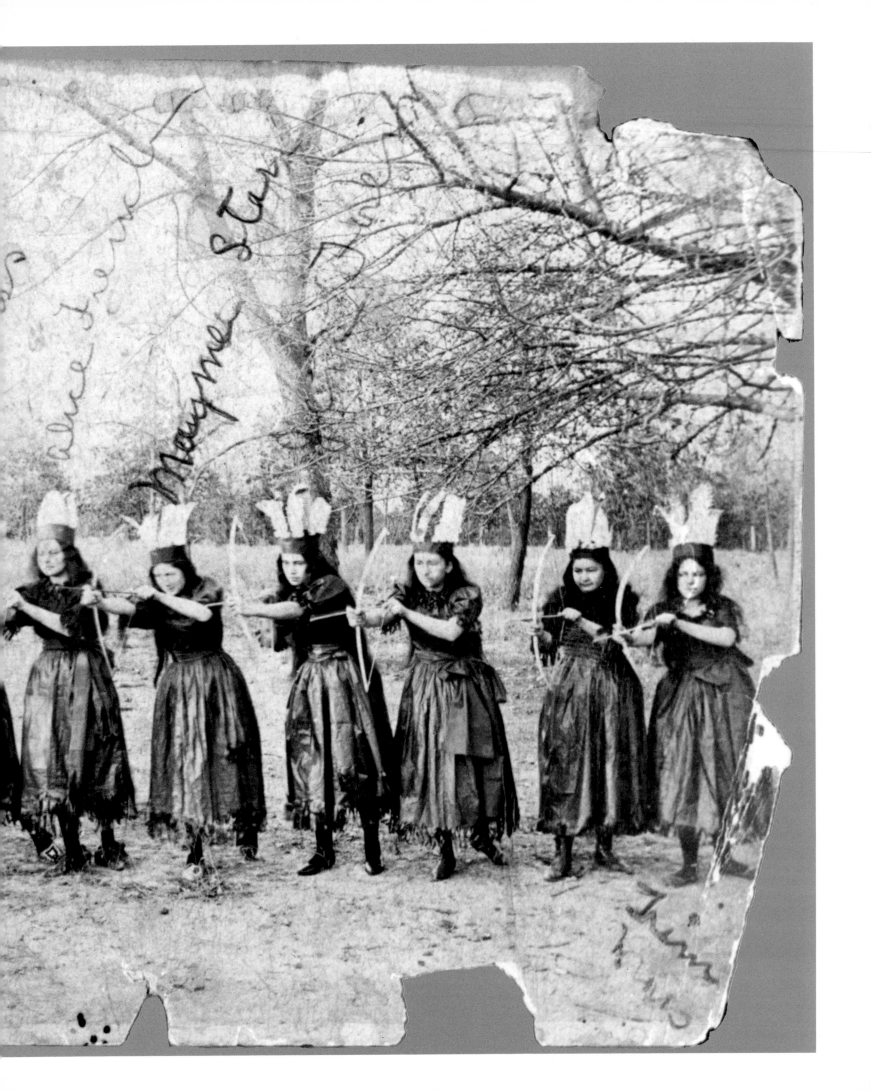

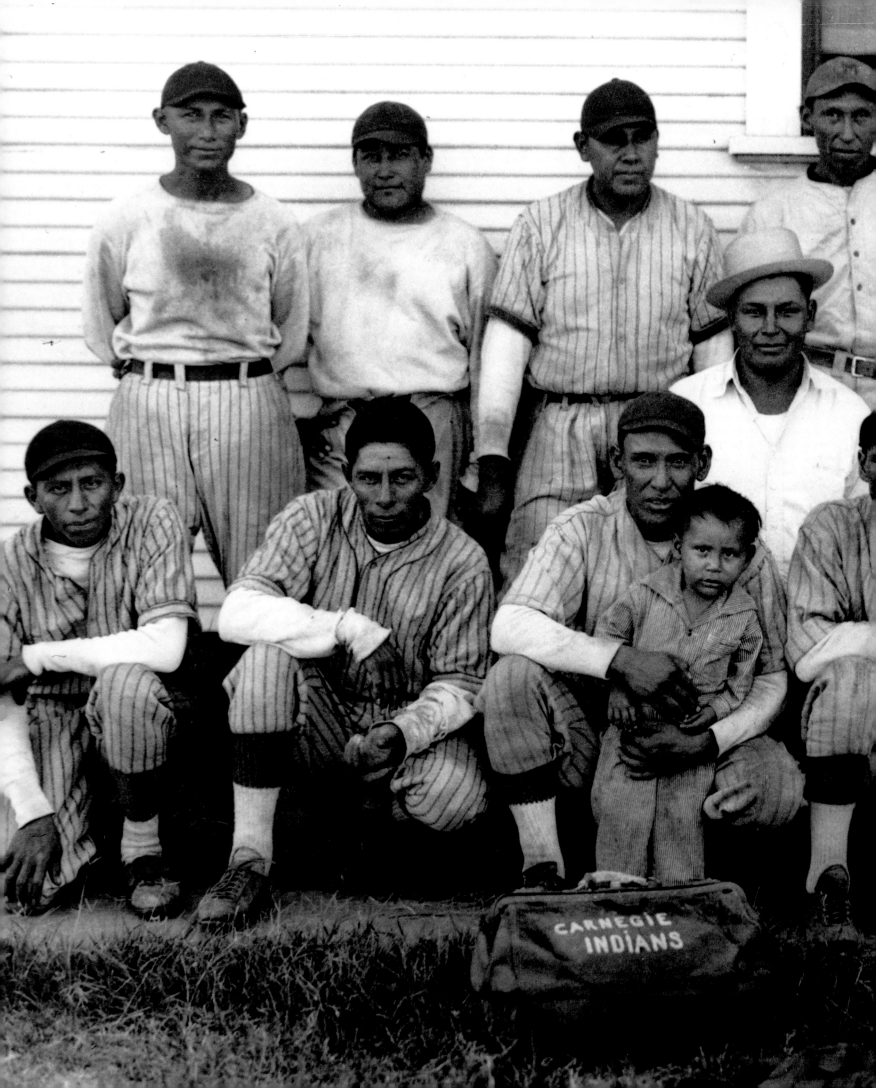

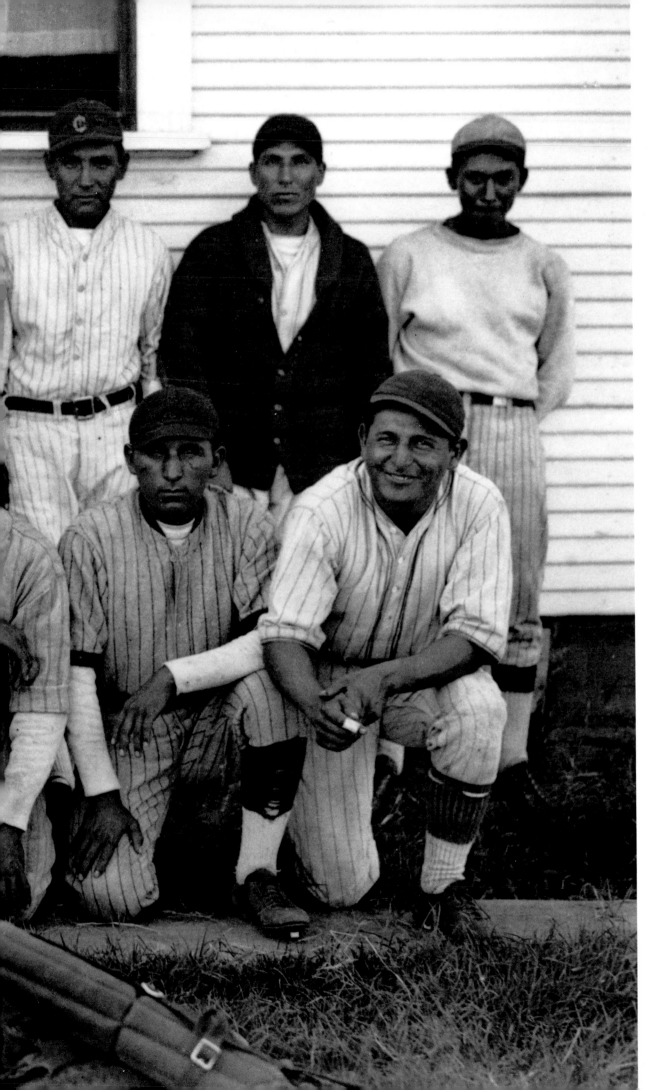

Pages 12–18:
Horace Poolaw
(Kiowa)

Left:
Carnegie Indians
Baseball Team,
Carnegie, Oklahoma,
ca. 1933

13

THE PHOTOGRAPHY OF HORACE POOLAW

N. SCOTT MOMADAY

Horace Poolaw (1906–1984) was the son of Tsomah, my great-grandmother's sister, and Pohd-lok (pronounced "Pole-haw"), later Poolaw. Pohd-lok ("Old Wolf" in Kiowa) became known to the non-Indian community as "Kiowa George." He was a wonderful man, an arrow maker, the keeper of a calendar. He lived at that crucial time of change when the Plains culture was brought down and the Kiowa, along with other tribes, had to enter upon another, harder plane of existence. It was a brutal transition, an accommodation most difficult, final, and unforgiving.

Pohd-lok, one of whose wives was my great-grandmother, gave me my Indian name. Horace was a close friend of my parents and of mine. I remember him as a very kind and gentle man, a man of great generosity and loyalty. The last time I saw him, he was in a wheelchair on the apron of a dance ground near his home of Anadarko, Oklahoma. He had not much longer to live, but he greeted me with real enthusiasm and sincerity. It means something to me that I should have seen him for the last time in that setting, a celebration of Kiowa life, ceremony, and heritage.

Horace Poolaw was a photographer of the first rank. He knew, from the time he took up a camera in his hands, how to draw with light. His sense of composition, proportion, and symmetry were natural and altogether trustworthy. His vision of his world, perceived through the lens of a camera, was touched with genius. Looking at his life's work, we see that he was the equal of such frontier photographers as Edward Curtis, Charles Lummis, and William Soule; and in his native intelligence and understanding of the indigenous world, he surpassed them. He was an artist of exceptional range and accomplishment, and he has given us a unique vision of American life.

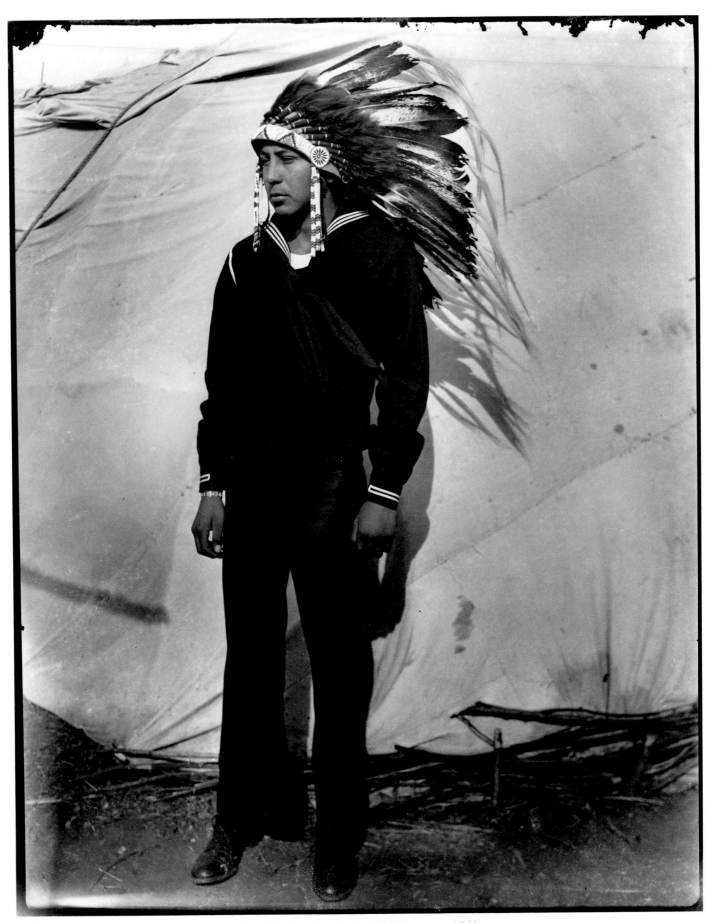

Jerry Poolaw, Anadarko, Oklahoma, ca. 1944

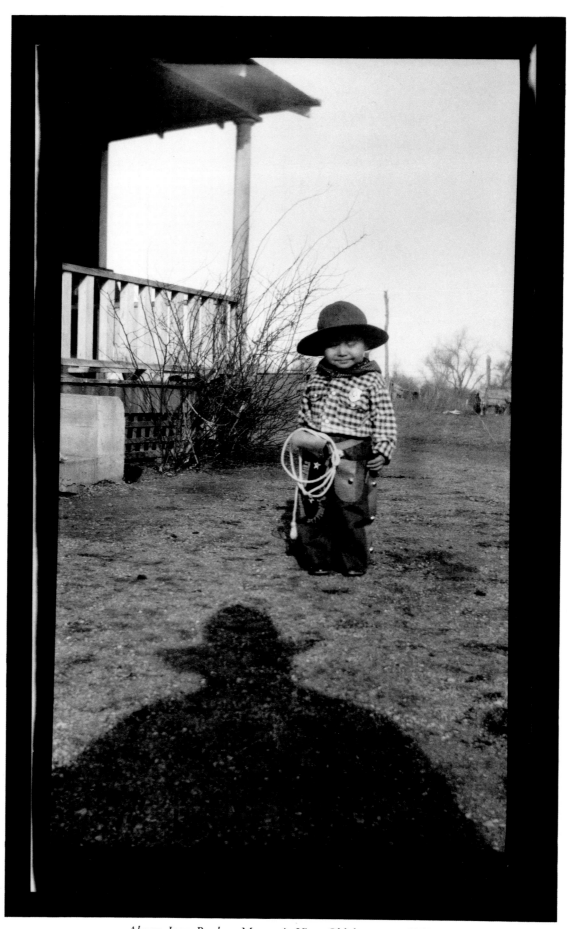

Above: Jerry Poolaw, Mountain View, Oklahoma, ca. 1929
Opposite: Kiowa Group in American Indian Exposition Parade, Anadarko, Oklahoma, ca. 1941

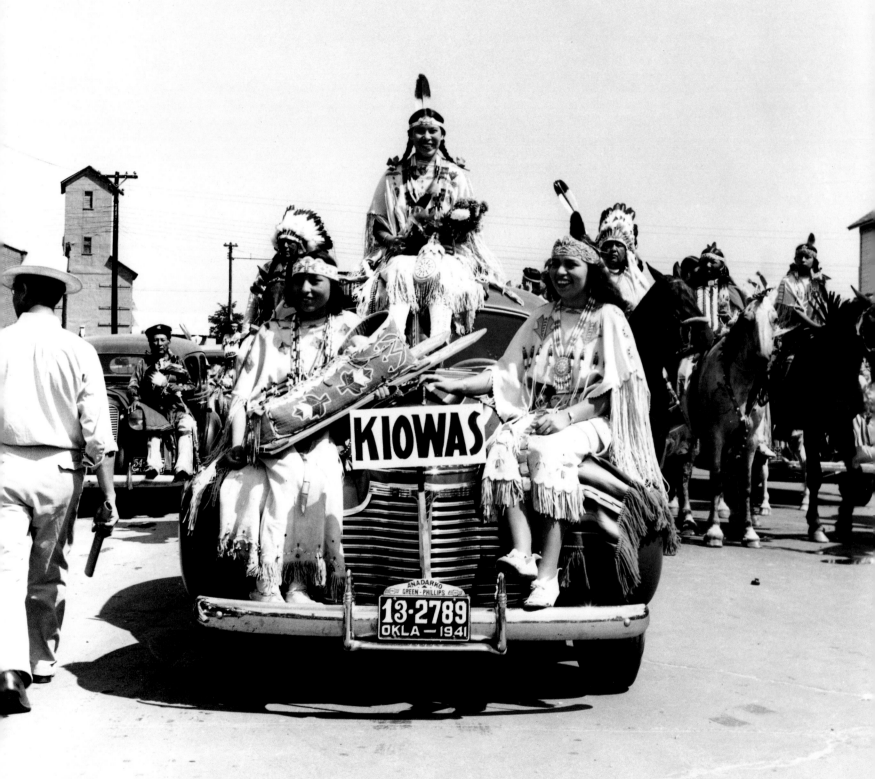

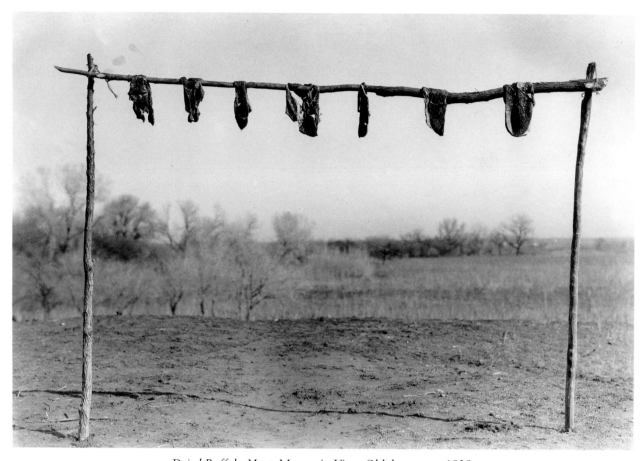

Dried Buffalo Meat, Mountain View, Oklahoma, ca. 1928

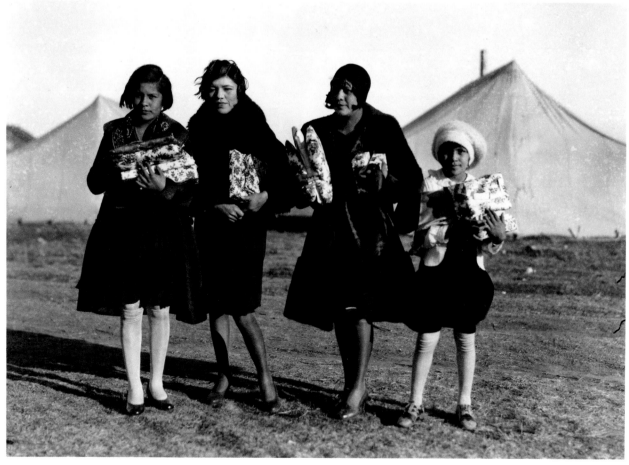

Evelyn Saunkeah, Lucy Apheatone, Nell Saunkeah, Vivian Saunkeah, Mountain View, Oklahoma, ca. 1930

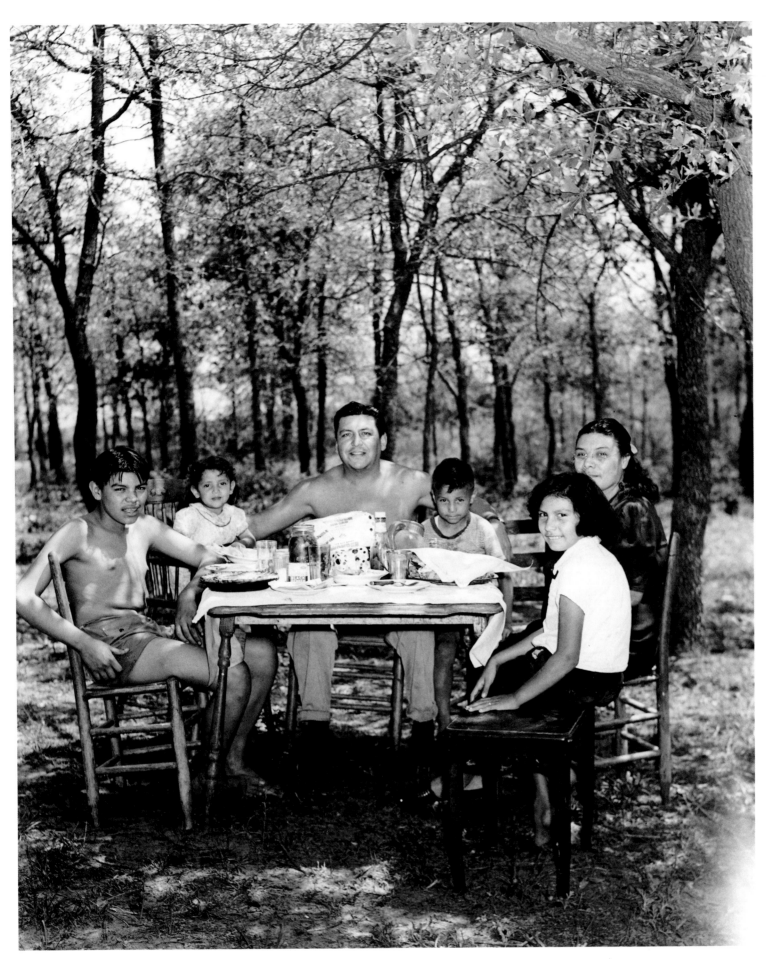

Winnie Poolaw, *Horace Poolaw with his Children and his Sister-In-Law with her Children*, Anadarko, Oklahoma, ca. 1945

CREATING A VISUAL HISTORY:
A QUESTION OF OWNERSHIP

BY THERESA HARLAN

PHOTOGRAPHS BY LEE MARMON AND MAGGIE STEBER

In 1992 I guest curated "Message Carriers: Native Photographic Messages" for the Photographic Resource Center at Boston University.[1] When invited, I could not accept without careful consideration of significant issues such as: ghettoization, opportunism (mine and theirs), and exploitation. Mainstream museums and publications often set apart "artists of color," "multicultural artists," and "ethnic artists," thereby designating us as the "other" or "different." The art and writings of these "other" artists are locked into discussions of "their" art, "their" people, and "their" issues. While there are still few opportunities to exhibit works by Native artists, there are even fewer exhibitions that treat these works in terms of their intellectual and critical contributions. Contemporary Native art is often characterized as angry, created from the voices of the defeated, and confined to the realm of the emotions.

Native people have—but are not perceived as having—diverse histories, cultures, languages, economics, politics, and worldviews. As Native people, we must claim rights to, and ownership of, strategic and intellectual space for our works. We must reject the reduction of Native images to sentimental portraits, such as those depicted by Marcia Keegan in her book *Enduring Culture: A Century of Photography of the Southwest Indians.*[2] Keegan writes, "From the beginning of my acquaintance with them, it was the Indians' confidence and attunement to the eternal verities that inspired my wonder and admiration. Thus it became my enduring commitment to try to experience, imagine, and document that more elusive subject, the traditional Indian way of life."[3] This type of thinking reduces Native survival to a matter of nostalgia, and precludes discussion of the political strategies that enabled Native survival. The writer bell hooks refers to nostalgia as "that longing for something to be as once it was, a kind of useless act. . . ."[4] and calls for the recognition of the politicized state of memory as ". . . that remembering that serves to illuminate and transform the present."[5]

Native survival was and remains a contest over life, humanity, land, systems of knowledge, memory, and representations. Native memories and representations are persistently pushed aside to make way for constructed Western myths and their representations of Native people. Ownership of Native representations is a critical arena of this contest, for there are those who insist on following the tired, romantic formulas used to depict Native people. Those myths ensure an existence without context, without history, without a reality. An existence that allows for the combing of hair with yucca brushes in the light of a Southwest sunset; competition powwow dancing reborn as a spiritual ceremony; or the drunken Indian asleep on cement city sidewalks unable to cope with the white man's world. These are the representations constantly paraded before us by non-Native photographic publications such as Keegan's *Enduring Culture*, or *National Geographic*'s 1994 issue on American Indians, or Marc Gaede's *Border Towns*. Such constructed myths and representations are given institutional validation in the classroom and are continually supported by popular culture and media.

American classrooms are usually the first site of contest for Native children. In her essay, "Constructing Images, Constructing Reality: American Indian Photography and Representation," Gail Tremblay writes, "When Native children are taught that they are not equal, that their cultures are incapable of surviving in a modern world, they suffer from the pain that has haunted their parents' lives, that haunts their own lives. For an indigenous person, choosing not to vanish, not to feel inferior, not to hate oneself, becomes an intensely political act. A Native photographer coming to image making in this climate must ask, 'What shall I take pictures of, who shall I take pictures for, what will my images communicate to the world?'"[6]

Photographer and filmmaker Victor Masayesva, Jr., has described the camera as a weapon. "As Hopi photographers, we are indeed in a dangerous time. The camera which is available to us is a weapon that will violate the silences and secrets so essential to our group survival."[7] Writer, curator, and photographer Richard Hill, Jr. of the Tuscarora nation, also named the camera as a weapon, but a weapon for "art confrontation rather than military confrontation. Indians themselves now have taken the power of the image and begun to use it for their own enjoyment as well as for its potential power as a political weapon."[8] Artist Hulleah Tsinhnahjinnie declared, "No longer is the camera held

by an outsider looking in; the camera is now held with brown hands opening familiar worlds. We document ourselves with a humanizing eye, we create new visions with ease, and we can turn the camera and show how we see you. The power of the image is not a new concept to the Native photographer—look at petroglyphs and ledger drawings. What has changed is the process."[9]

Masayesva, Hill, and Tsinhnahjinnie speak from the experience of seeing themselves spoken for by outsiders, of seeing the surreal positioned as the real. As Trinh T. Minh-ha says, Native image-makers "understand the dehumanization of forced-removal/relocation/re-education/re-definition, the humiliation of having to falsify your own reality, your voice—you know. And often cannot say it. You try and keep on trying to unsay it, for if you don't they will not fail to fill in the blanks on your behalf, and you will be said."[10]

When Native people do pick up the camera, often their image making is greeted with a patronizing welcome. The "Indian" no longer sits passively before the camera, but now operates the camera—a symbol of the white man's technology. The voices and images of Native photographers must be understood as rooted in and informed by Native experiences and knowledge.

Lee Marmon has created, and continues to create, photographic representations of Native people that affirm Native memories, self-knowledge, and presence. Upon his return from World War II, Marmon began taking photographs of the old people in the villages at Laguna Pueblo—so that there would be something to remember them by. Marmon's photographic remem-

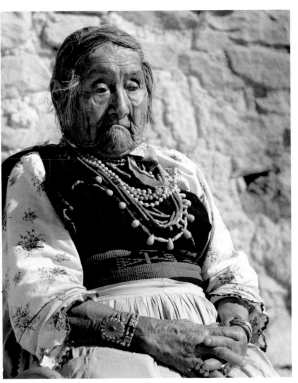

Lee Marmon, *Juana Scott Piño*, Laguna Pueblo, 1959

brances are of a generation of people who had to devise ways to affirm and protect Laguna knowledge despite the pernicious attempts—beginning in the sixteenth century—of the Spanish, Mexican, and later, the United States governments to strip them of land, culture, religion, and the memory of that existence. Thus, these are not merely images of cute old people. The presence of Juana Scott Piño; of Jeff Sousea in *White Man's Moccasins;* or of Bennie at the sheep camp might at first seem ironic or contradictory, as some are dressed in "traditional" clothing and others not. Marmon's photography is not confined to any strict notion of Indianness. It differs vastly from Keegan's inspired commitment to document the "elusive traditional way of life," as these images include the context of Laguna lives and experiences. Marmon did not drive around seeking the best adobe wall to use as a background; he photographed his community while delivering groceries for his family's store.[11] What we see through Marmon's photographs are images of people living and working as they are—and

without an implied mystical "elusiveness." Marmon's title, *White Man's Moccasins,* is more than the irony of an old Laguna man wearing high-tops. It is Pueblo objectification of Western society through the appropriation of a popular Western icon.

Marmon's images are of people who do not perceive themselves as confined to any mythic or imagined concepts held by others. They remain fresh because they are not restricted by essentialist notions that Native people must dress as Natives in order to look Native and to be Native. Even some Native documentary photographers fall prey to expressing Native thinking and traditions through what is worn. By doing this, they risk entering into the same trap of only being able to recognize themselves through the eyes of non-Natives.

Zig Jackson provides ethnographic material about non-Native practices in photographing Native people in his series "Indian Photographing Tourist Photographing Indian." The tourists he records are so intent on their subjects and the drama of the moment that they are unaware of Jackson's presence. They exhibit a fascination usually reserved for movie stars, rock stars, scandalized politicians, or famous athletes. For these photographers, the value of Native images is based strictly on appearance. But would they clamor to take pictures of Native people wearing the clothes they wear at school, work, or home? No. Because when Native people wear bright colors, fringe, beads, leather, and feathers, they are "real" Indians. When they are dressed in everyday clothes they are not. Robert Berkhofer, Jr., discussed this in *The White Man's Indian: Images of the American Indian from Columbus to the Present.* "Since Whites primarily understood the Indian as an antithesis to themselves, then civilization and Indianness as they defined them would forever be opposites. Only civilization had history and dynamics in this view, so therefore Indianness must be conceived as ahistorical and static. If the Indian changed through the adoption of civilization as defined by Whites, then he/she was no longer truly Indian according to the image, because the Indian was judged by what Whites were not. Change toward what Whites were made him [her] ipso facto less Indian."[12]

Larry McNeil deliberately avoids representations of the "feathered" Indian and instead chooses a single feather to discuss Native survival. Some critics have described this work as relying on an easily recognized symbol, even a cliché. In fact, to reduce McNeil's use of feathers to a cliché is to accept the dominant thinking that is continually wielded against Native people. (Dominant thinking prevails when Native symbols are reduced to cliché while American

colonization continues to be described as Manifest Destiny.) In McNeil's series, Native survival deliberately is not shown through full-color images of powwow dancers. Instead, he keeps to the visceral side of survival through black-and-white depictions of worn and broken feathers set against a dark background. Here, the Native memory of survival is neither romantic nor nostalgic.

James Luna's photo-essay "I've Always Wanted to Be an American Indian," is a satirical jab at those who at some point discover a thread of Native ancestry in their past and then draw on myths of Indian identity to realize their ancestral inheritance. Luna's wake-up call is for these individuals to realize the reach of racist, political, and economic subordination of Native people, who cannot pick and choose their Native circumstances. Luna escorts the wake-up Indian on a guided tour of his La Jolla reservation, pointing out interesting sites and bits of information. His snapshot photographs of the mission church, schoolchildren, and a disintegrating adobe building are combined with positive and negative snips of information. Statements such as "During the last five years on the Reservation there have been and/or are now: three murders, an average unemployment rate of 47 percent, . . . twenty-one divorces and/or separations . . . thirty-nine births, forty-five government homes built . . . an increase in the percentage of high school graduates."[13] At the end of the tour, Luna asks "Hey, do you still want to be an Indian?"

Hulleah Tsinhnahjinnie reveals the current dispute among Native people over who, in fact, is "Indian." Tsinhnahjinnie's *Would I Have Been a Member of the Nighthawk, Snake Society or Would I Have Been a Half-Breed Leading the Whites to the Full-Bloods*, signed "111-390" (her issued tribal enrollment number) uses self-portraiture to discuss identity politics within a historical context. These graphic, 40-by-30-inch, black-and-white head-and-shoulder shots, which resemble passport or police photographs, support her discussion of the use of photography to identify and control the "other." The reference to the Nighthawk, Snake societies, and half-breeds comes from a 1920 statement made by Eufala Harjo regarding the practice of the Bureau of Indian Affairs of securing names of Creek, Chickasaw, Choctaw, and Cherokee resistance-group members from "half-breed" informants.[14] Societies were formed to resist tribal leaders' decisions to ignore previous treaty agreements and to accept the 1887 Dawes Allotment Act, which reallocated parcels of lands to individual ownership—thereby overturning tribal practices of land collectively held through the maternal line.

Tsinhnahjinnie is one of the few artists who have taken a public stand on the 1990 Indian Arts and Crafts Act, which requires tribal enrollment numbers, state census roll numbers, or a special "Indian artist" status to be provided by an artist's tribal council in order for Native artists to sell their work as "Indian" art. Tsinhnahjinnie reminds us that we, as Native people, must recognize and understand identity politics as the invention of the United States government.

Pages 22–27: Lee Marmon (Laguna)
Right: *Laguna Eagle Dancers*, 1949

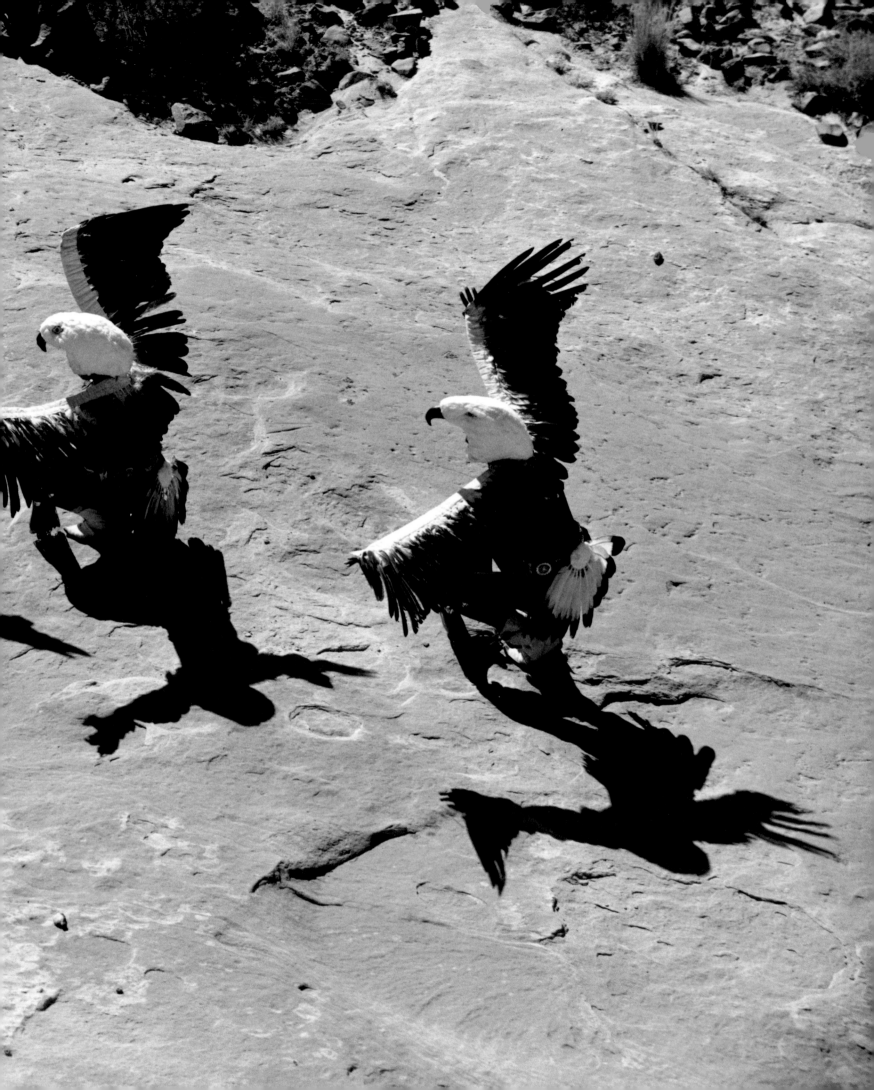

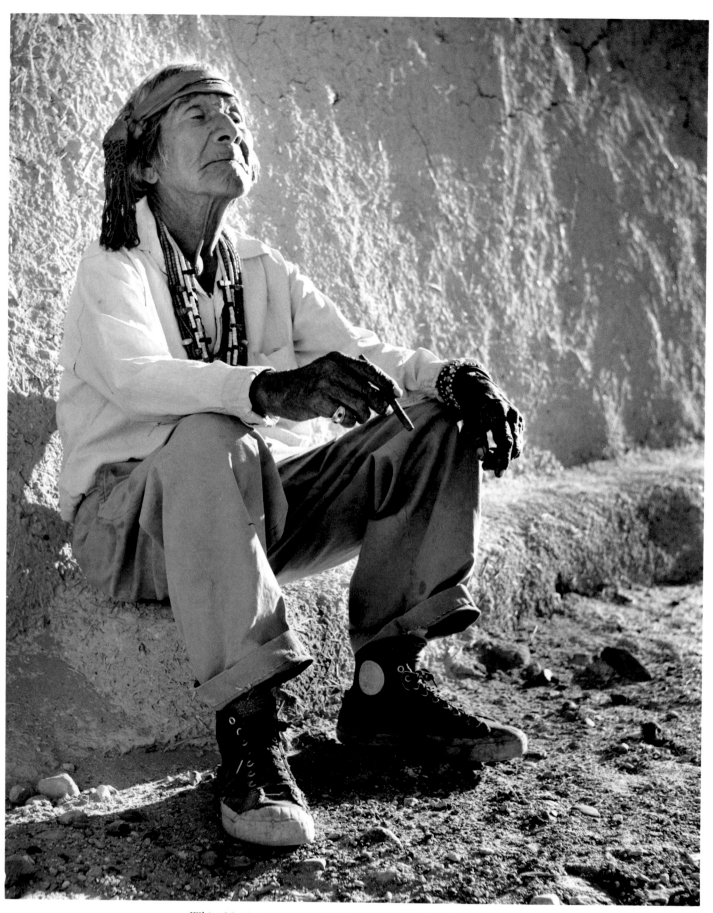

White Man's Moccasins, *(Jeff Sousea)*, Laguna Pueblo, 1954

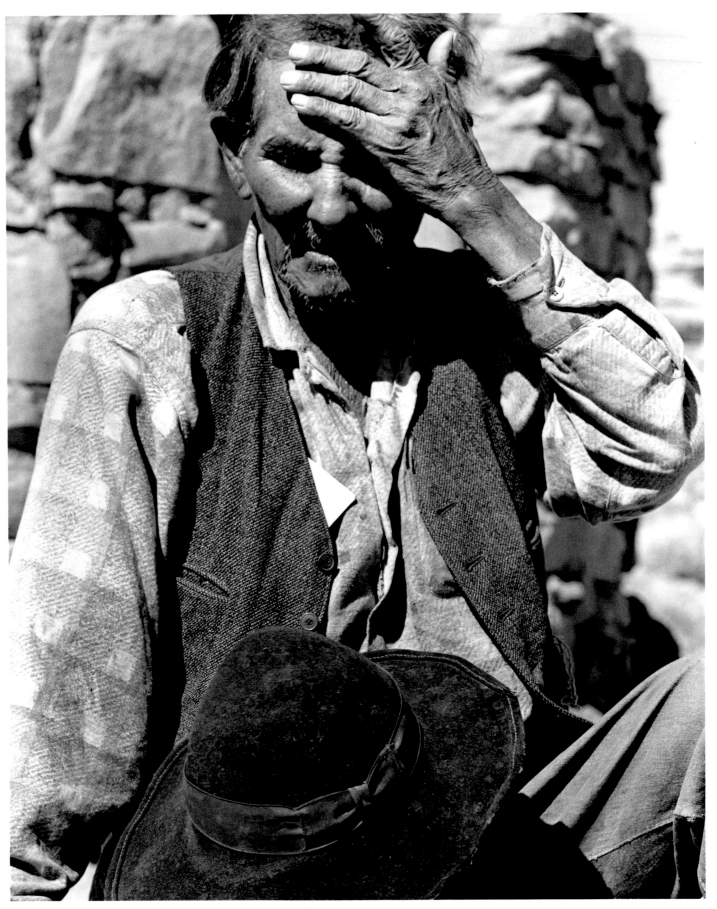

Platero, Navajo, 1958

Jolene Rickard's *Sweka and PCBs* calls our attention to the fact that we may be ignoring or underestimating the dangers that accompany moneyed solicitations of tribal land use for toxic dump sites that contaminate food sources. Rickard draws a connecting line from toxic contamination to the gathering, collecting, fishing, and hunting of foods, and the ritual ceremonies that emanate from those sources. Rickard warns us, "If Indians no longer have a material and spiritual relationship with 'land,' then certain teachings and ceremonies cannot take place. Even when it is possible to transform these teachings into abstract space, without the geographic place of community, experience has shown that the teachings increasingly dissipate."[15]

Sweka and PCBs is not a romantic representation of an Indian man and his relationship to the natural world. It is a warning for all of us to confront our own threatened survival as human beings. We may become our own endangered species along with the salmon and the eagle that feeds on the salmon.

In Pamela Shields Carroll's *Footprints*, family images are printed on cut-out soles of baby moccasins, along with porcupine quills, collected in a small wooden box. *Footprints* evokes family memories that ultimately inform the next generation. The image on the left sole is of Carroll's brother celebrating his third birthday, dressed as a cowboy, sitting on a pony. The right sole depicts Carroll's great-aunt's Sun Dance tipi. *Footprints* is layered with personal memories, but also speaks from historical experience. It is a sister's quiet memory of her brother—and a statement about non-Native influences. The complexity of growing up Native is revealed in a family snapshot, in which her brother, as a child, adopts the dress of those who were part of the conquest of his larger Blackfoot family. It is also a memory of family participation and responsibility in ceremony, and the health of a community through the Sun Dance. Yet together the moccasin soles represent diverse paths: the left, reflective of outside influences and future generations; the right, inside sources of knowledge and the integrity of Blackfoot culture.

Creating a visual history—and its representations—from Native memories or from Western myths: this is the question before Native image-makers and photographers today. The contest remains over who will image—and own—this history. Before too many assumptions are made, we must define history, define whose history it is, and define its purpose, as well as the tools used for the telling of it. The intent of history is to help us keep our bearings. That is, to know what is significant and, most importantly, to teach us *how* to recognize the significant. What happens when history is skewed, or when we no longer have the same skills of recognition? We as human beings become disabled by the inability to distinguish what is real from what is not. Gerald Vizenor, in his book *Manifest Manners: Postindian Warriors of Survivance*, calls this "Postindian simulations [which] are the absence of shades, shadows, and consciousness; simulations are mere traces of common metaphors in the stories of survivance and the manners of domination." *(continued on page 32)*

Bennie, Laguna Pueblo, 1984

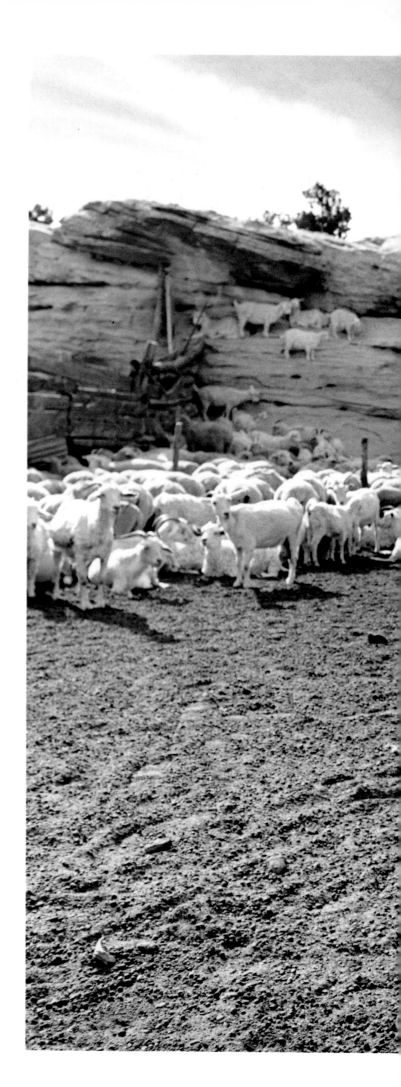

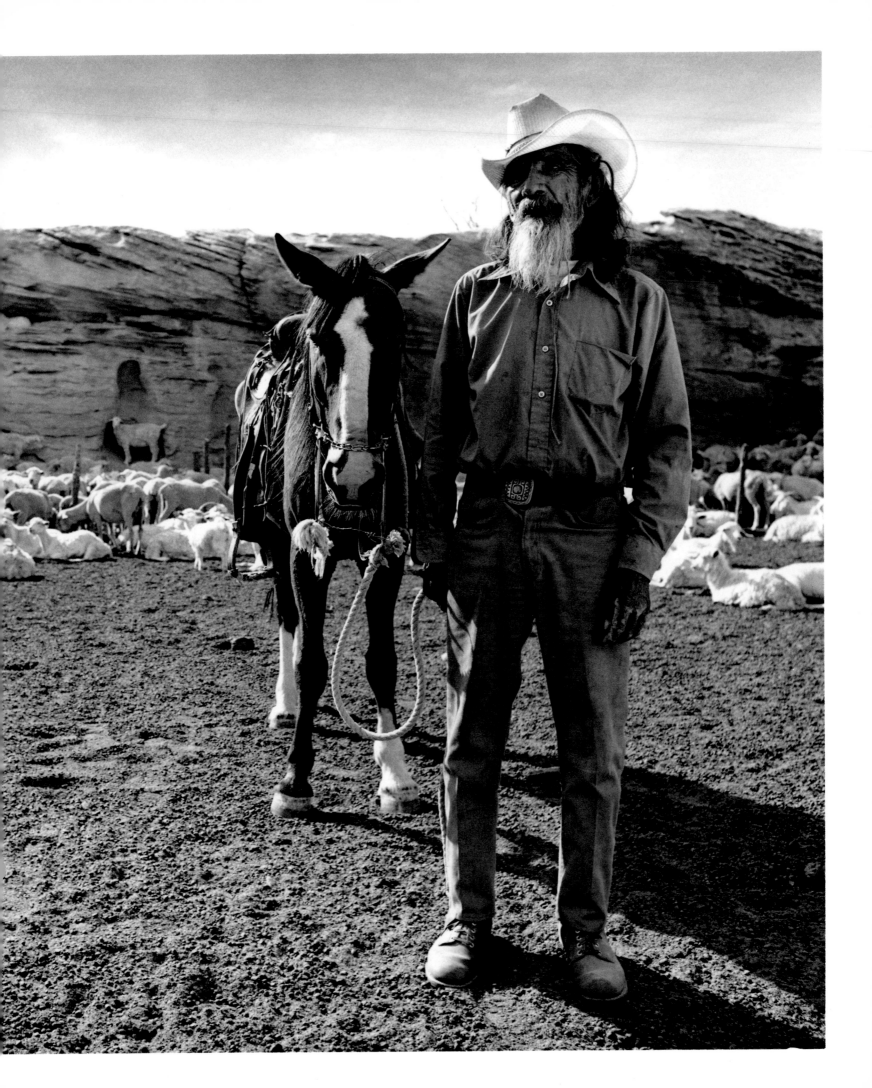

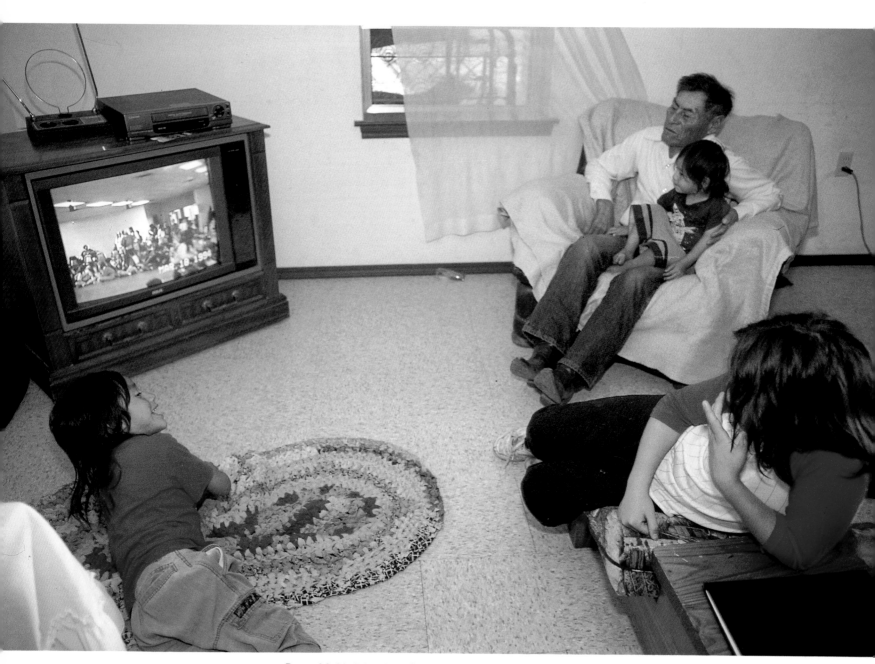

Pages 28-33: Maggie Steber (Cherokee ancestry), from the series
"An American Family," Tahlequah, Oklahoma, 1994

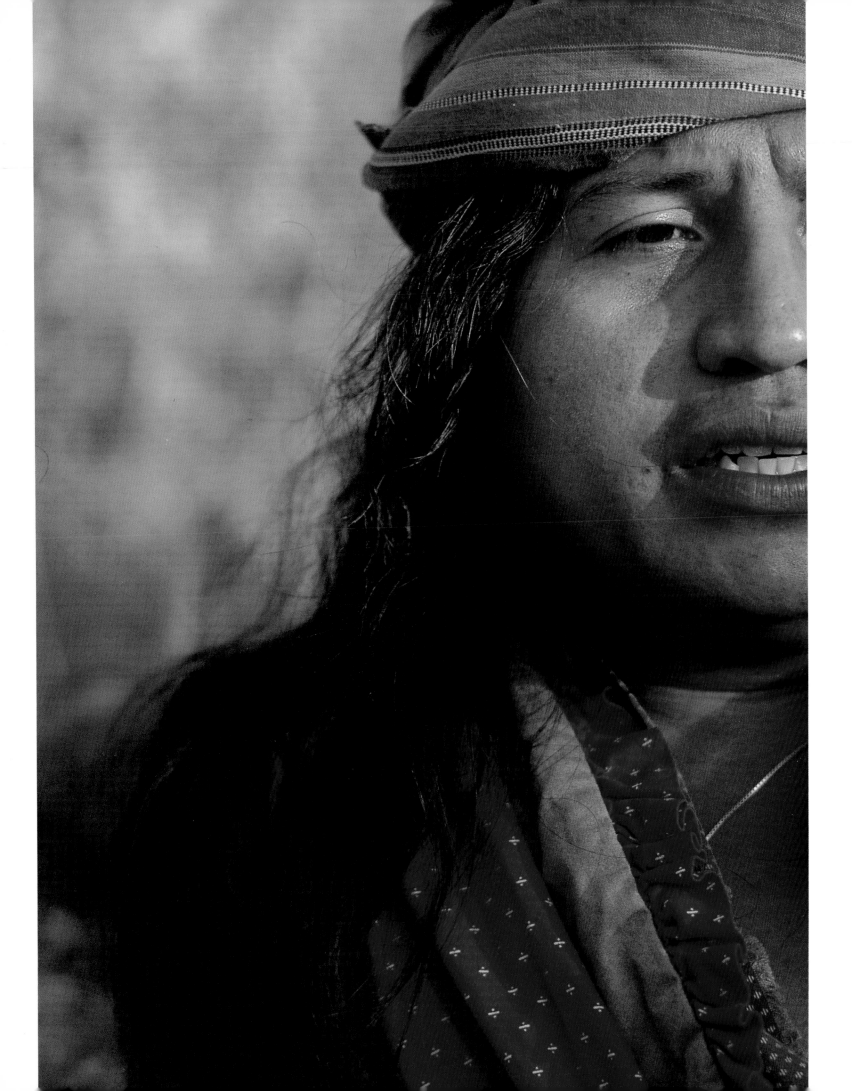

(continued from page 26)

What Native photographers provide is the possibility of a Native perspective unclouded by white liberal guilt or allegiance to Western heroes. Yet these possibilities are not guaranteed by race or genetics. For if the photographer picks up his or her camera and approaches image making with the same notions of capturing a "proud/primitive" moment, then we are not getting a Native perspective. We are seeing Euro-American image-making traditions in action in Native hands. Those images do not carry messages of survival. In fact they are an ominous signal that colonization has been effective, in that the "Indian" can now recognize him- or herself only through the outside, as an outsider.

Native image-makers who contribute to self-knowledge and survival create messages and remembrances that recognize the origin, nature, and direction of their Native existence and communities. They understand that their point of origin began before the formation of the United States and is directly rooted to the land. These Native image-makers understand that the images they create may either subvert or support existing representations of Native people. They understand that they must create the intellectual space for their images to be understood, and free themselves from the contest over visual history and its representations of Native people.

1. Gail Tremblay, "Constructing Images, Constructing Reality: American Indian Photography and Representation" in *Views: A Journal of Photography in New England* (Vol. 13–14, Winter 1993), p. 30.
2. "Message Carriers: Native Photographic Messages" was at the Boston Photographic Resource Center at Boston University in October, 1992. The exhibition included the works of Patricia Deadman, Zig Jackson, Carm Little Turtle, James Luna, Larry McNeil, Jolene Rickard, Hulleah Tsinhnahjinnie, and Richard Ray Whitman. Then staff curator Anita Douthat initiated the exhibition. The PRC was instrumental in the success of the exhibition.
3. Marcia K. Keegan, *Enduring Culture: A Century of Photography of the Southwest Indians* (Santa Fe: Clear Light Publishers, 1990), p. 11.
4. bell hooks, *Yearning, Race, Gender, and Cultural Politics* (Boston: South End Press, 1990), p. 147.
5. Ibid
6. Tremblay, p. 30.
7. Victor Masayesva, Jr., "Kwikwilyaqua: Hopi Photography," in *Hopi Photographers/ Hopi Images*, edited by Larry Evers (Tucson: *Sun Tracks*, University of Arizona Press, 1983), pp. 10–11.
8. Richard Hill, Jr. quoted in Susan R Dixon, "Images of Indians: Controlling the Camera," in *North East Indian Quarterly* (Spring/Summer, 1987), p. 25.
9. Hulleah J. Tsinhnahjinnie, "Compensating Imbalances," in *Exposure* 29 (Fall 1993), p. 30.
10. Trinh T. Minh-ha, *Women Native Other: Writing Postcolonialilty and Feminism* (Indianapolis: Indiana University Press, 1989), p. 80.
11. Lee Marmon owns and manages the Blue Eyed Indian Bookshop at Laguna Pueblo.
12. Robert Berkhofer, Jr., *The White Man's Indian: Images of the American Indian from Columbus to the Present* (New York: First Vintage Books Edition, A Division of Random House, 1979), p. 29.
13. James Luna, *Art Journal* (Vol. 51, No. 3, Fall 1992), pp. 23–25.
14. For further discussion see Angie Debo's *A History of the Indians of the United States* (Norman: University of Oklahoma Press, 1990).
15. Jolene Rickard, "Frozen in the White Light," in *Watchful Eyes: Native Women Artists* (Phoenix: Heard Museum, 1994), p. 16.
16. Gerald Vizenor *Manifest Manners: Postindian Warriors of Survivance* (Hanover, N.H. and London: Wesleyan University Press, University Press of New England, 1994), p. 53.

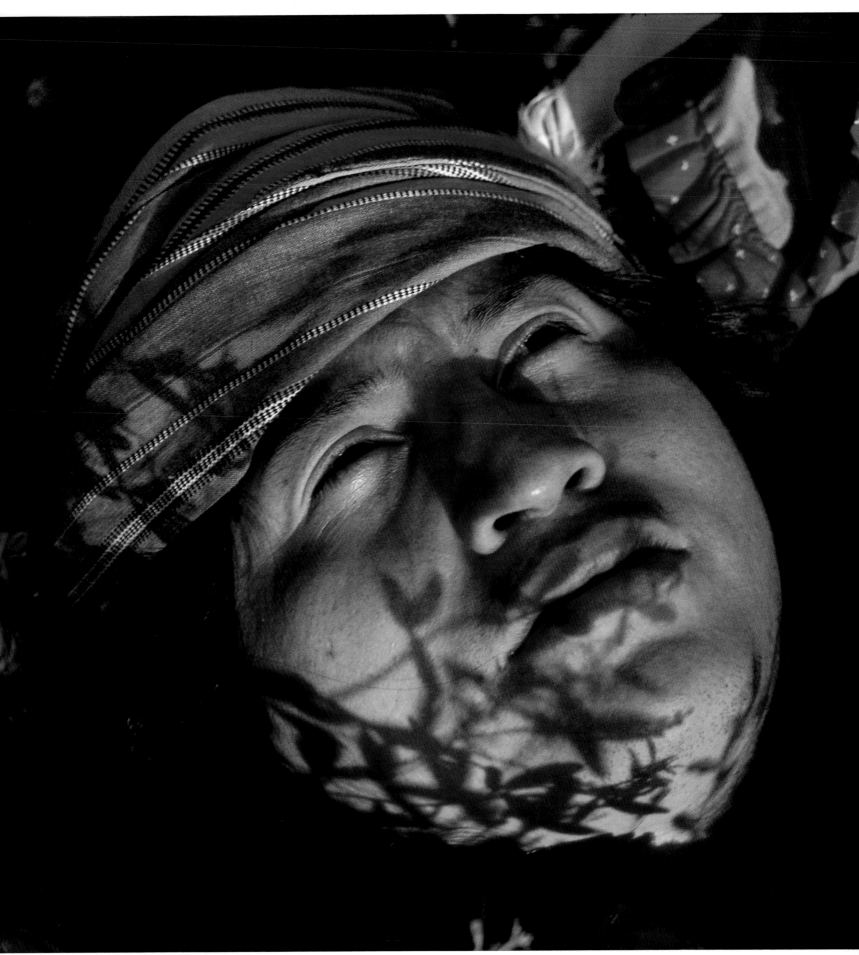

SOCIAL IDENTITY: A VIEW FROM WITHIN

PHOTOGRAPHS BY ZIG JACKSON

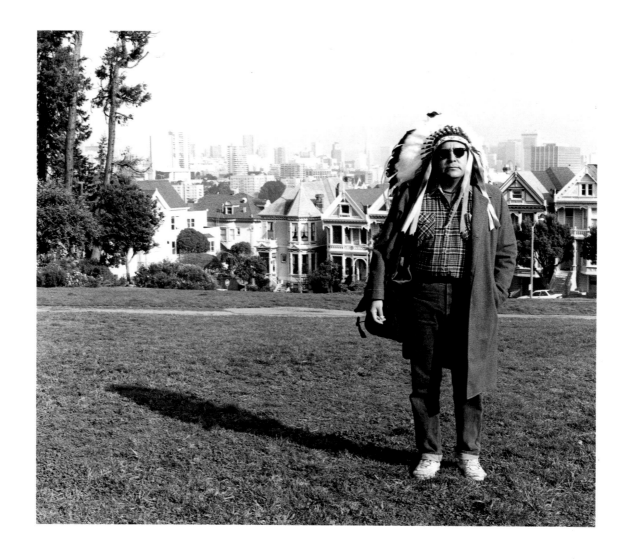

*Zig Jackson began the series "Indian Man in San Francisco" when he moved from rural New
Mexico to San Francisco. Humorous on the surface, the series refers to the devastating consequences of the Bureau
of Indian Affairs relocation program, in effect from the 1930s to the 1960s. Touted as a means of education and a way for
Indians to become assimilated into "mainstream America," the policy effectively banned the practice of native customs and
rituals. Jackson, who grew up in a traditional community, attended government-sponsored Indian boarding schools.
"First, our lands and traditions were taken away," he says. "Then, as children, we were separated from
our families and communities. The boarding-school system was another example of the U.S. government's
'divide and conquer' policies, ensuring that Indians remained an invisible, 'vanished' race."
In the series "Indian Photographing Tourist Photographing Indian," Jackson shows that the exploitation
of Native people by intrusive tourists is much the same today as it was one hundred years ago.*

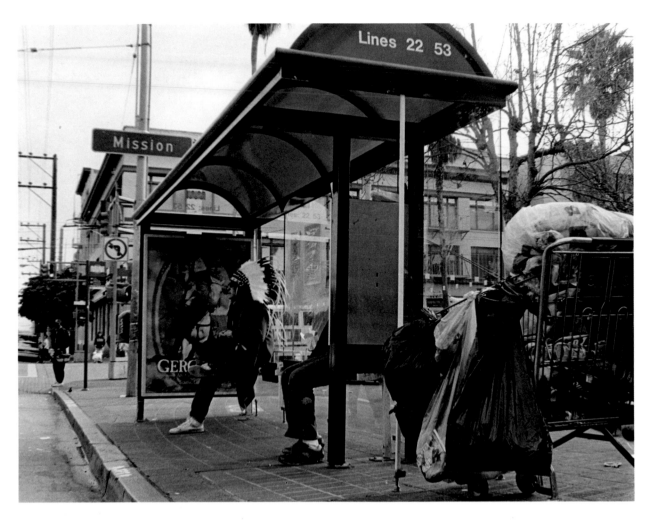

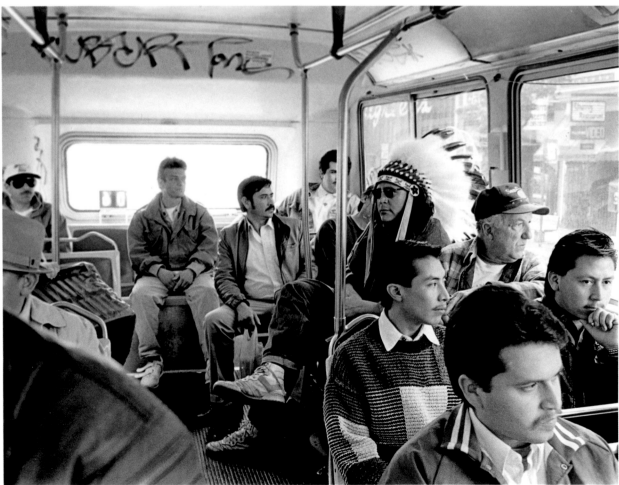

Pages 34–35: Zig Jackson (Mandan/Hidatsat/Arikara), from the "Indian Man in San Francisco" series, 1993

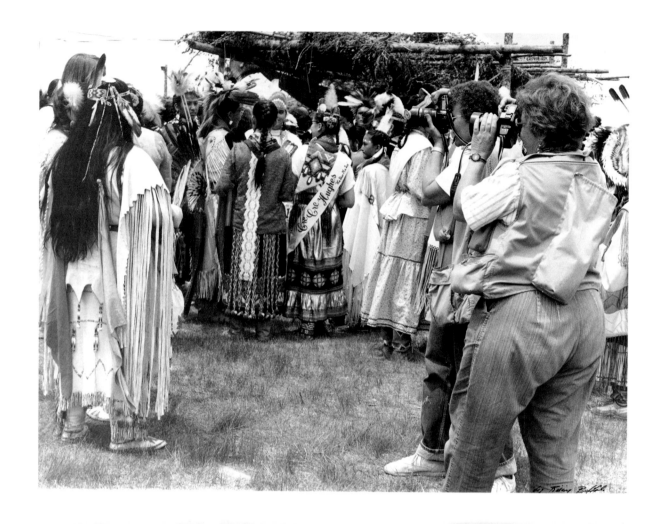

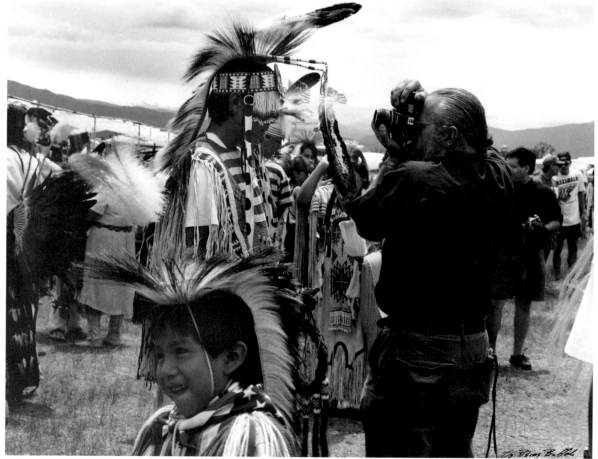

Pages 36–37:
Zig Jackson
(Mandan/
Hidatsat/
Arikara), from
the "Indian
Photographing
Tourist
Photographing
Indian" series,
1991

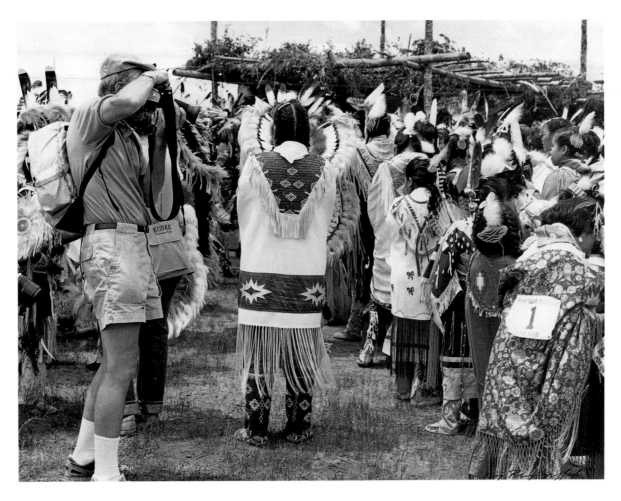

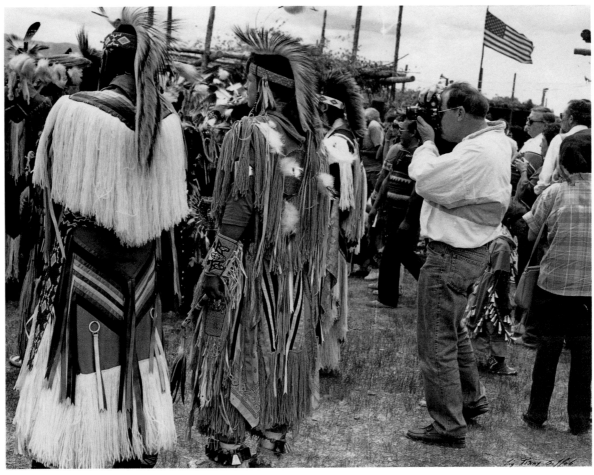

Pages 38–41: James Luna (Luiseño), from *I've Always Wanted to Be an American Indian*, 1992

I'VE ALWAYS WANTED TO BE AN AMERICAN INDIAN

PHOTOGRAPHS AND TEXT BY JAMES LUNA

I had heard this before, but for whatever reason the quote affected me not like before: the White Man looked me in the eye and quite honestly said, "Gee, I've always wanted to be an American Indian."

The La Jolla Indian Reservation, where I live, is but one of the seventeen reservations in North County, California, one of over three hundred federal reservations in the United States. It is a small reservation, as reservations go, yet quite typical of the contemporary Indian life-style. The reservation is composed of 8,541.25 acres, and of the 532 enrolled members, 355 of them are living here. The majority of people living here are Luiseño Indian, but we now also have other tribes, some that have become part of our families. The tribal groups that are represented here are: Sioux, Navajo, Hopi, Cherokee, Mojave, Diegueno, Cupeno, Shoshone, Miwok, Wailaki and Cahuilla. There are, at this writing, 121 dwellings in which we reside.

During the last five years on the
Reservation there have been and/or are now:

Two men who have lost limbs due to diabetes

THREE MURDERS

An average unemployment rate of 47 percent

Fourteen deaths

Four tribal members in prison or jail:
One for thirty years
One for ten years
One for seven years
One for two years or more

Cases of diabetes for 42 percent of the tribe

Seven reported cases of cancer

Shootings of four people

Twenty-one divorces and/or separations

Seven youths caught stealing cars

Twenty percent of the residents on welfare

Seven people admitted for mental observation

Two vacant government homes

AND . . .

Thirty-nine births
Forty-five government homes built
A tribally run store and campground
A raceway built on a tribal member's property
A developing volunteer fire department
Two people who have graduated with master's degrees
One who has graduated with a bachelor's degree
A tribally owned and operated water park
Four established artists
One singer
An increase in the percentage of high-school graduates

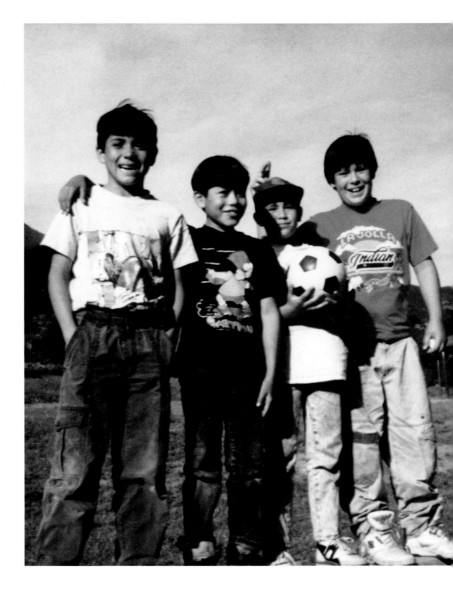

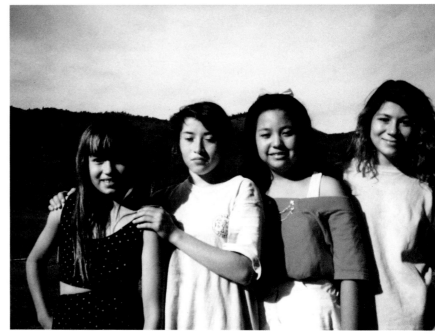

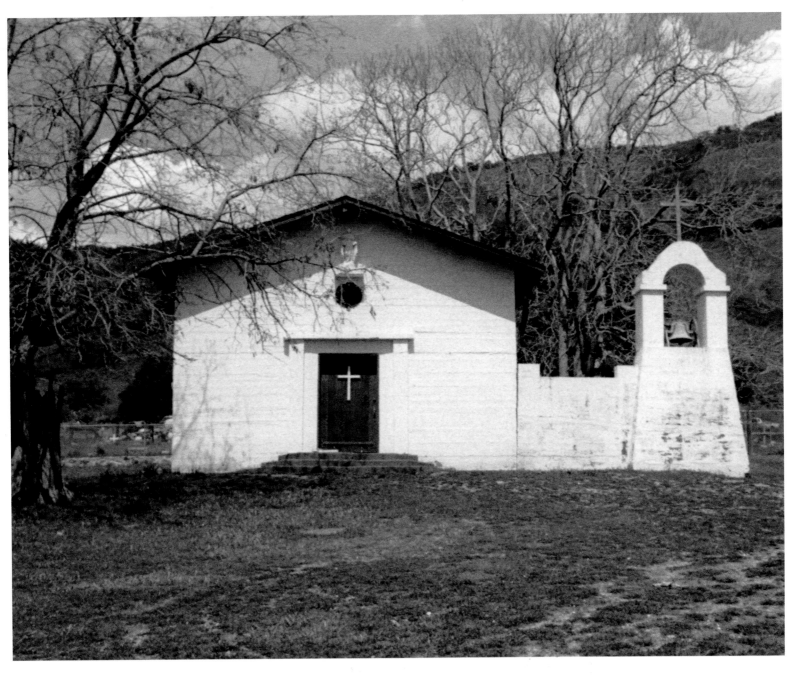

There is much pain and happiness, there is success and there is failure, there is despair and there is hope for the future. Still I would live no place else because this is my home, this is where my people have come. I also know that this place, like other places, is the reality that we Indians live; this is it. This isn't the feathers, the beads of many colors, or the mystical, spiritual glory that people who are culturally hungry want.

Hey, do you still want to be an Indian?

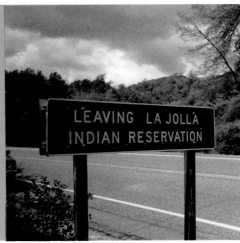

SHOOTING BACK FROM THE RESERVATION

PHOTOGRAPHS BY NATIVE AMERICAN CHILDREN

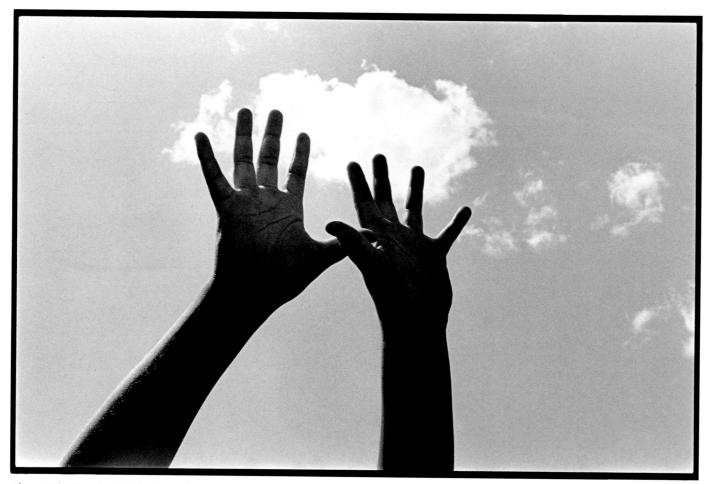

Above: John Stands, 11, *Hands in Sky,* Rapid City, South Dakota, 1992, *Opposite:* Bethany Nez, 14, *Janelle,* Window Rock, Arizona, 1992

CLOUDS

If I touch the clouds it would feel invisible
You will fall through. It feels soft
It looks like a person laying down on the clouds
It looks bluish-white and it tastes like water
It would look like the wind and I heard it blowing fast
It would taste like cotton candy and water
It looks like it was blowing up and it was round.

TASHINA MARTINEZ, 9, 1992

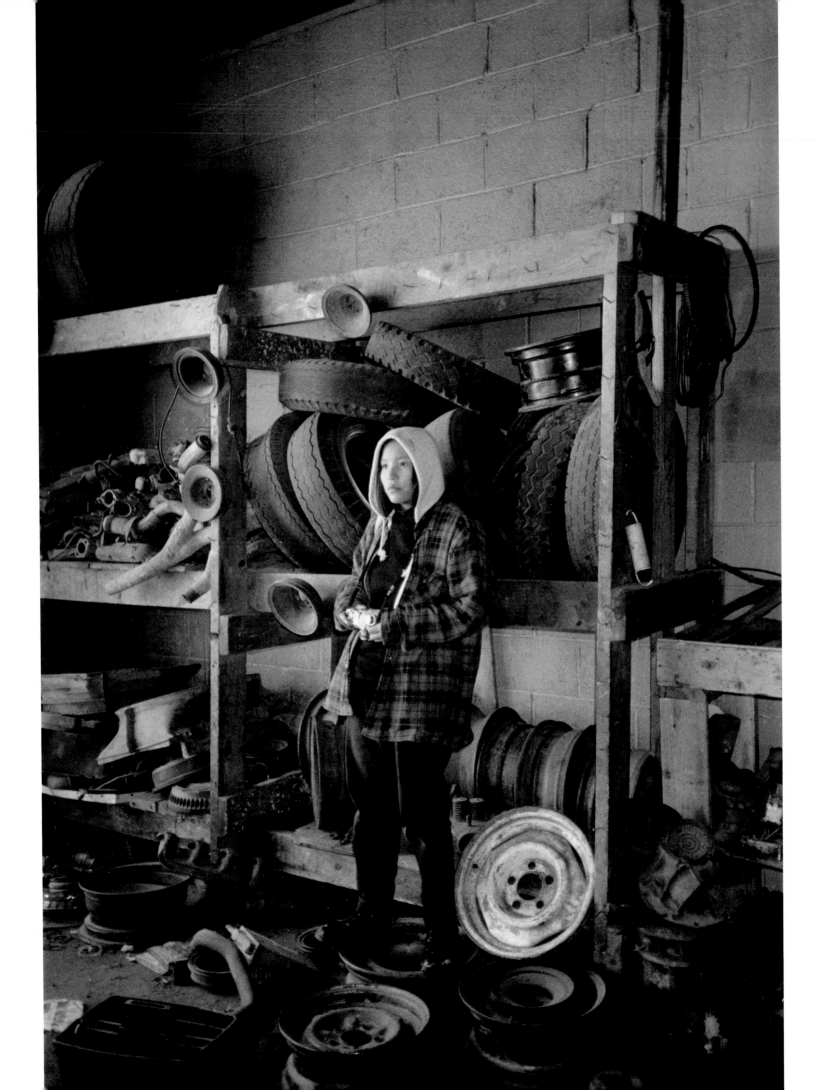

"The human spirit is enormously
powerful, intelligent, and creative.
These young photographers showed us
how important their dreams of hope,
self-confidence, wisdom, and
beauty are. In no way do I believe that
photography is a panacea, or
salvation from poverty and indifference.
These childrens' futures are uncertain.
Their visions, however, have much to
teach our society, and we must be
open to their messages, expressed here
in photographs and words."

— JIM HUBBARD,
Executive Director,
Shooting Back from
the Reservation

Ronald Lewis, Jr., 10, *Skull*, Hualapai Reservation,
Peach Springs, Arizona, 1993

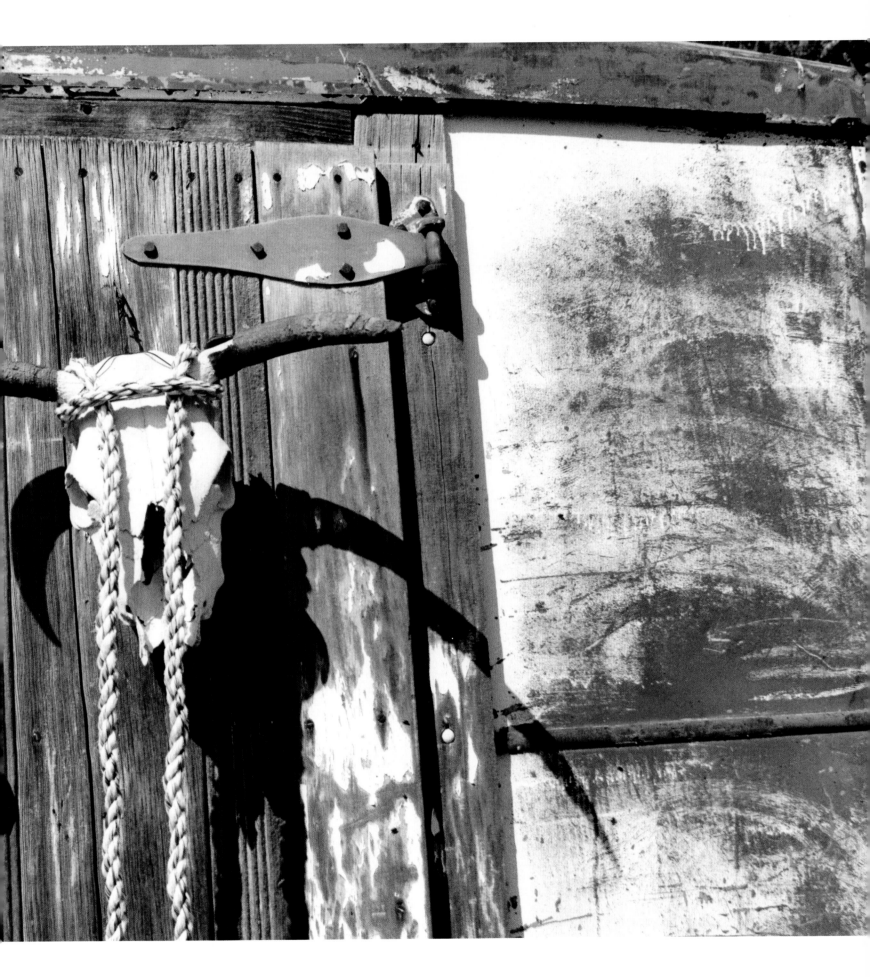

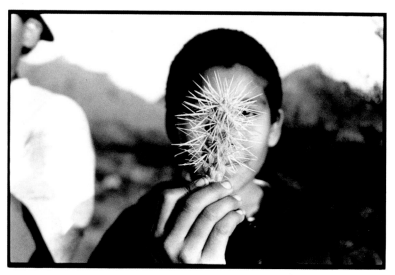

Monica Godoy, 10, *The Dead Cactus,* Tucson, Arizona, 1993

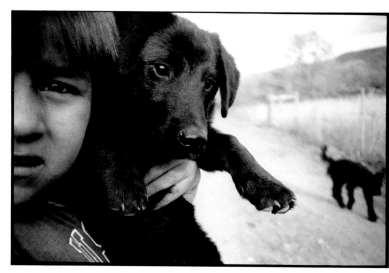

Joseph Concha, 10, *A Boy and His Dog,* Taos Pueblo, New Mexico, 1992

David Galaz, Jr., 13, *Hiding Faces,* Old Pasqua Yacqui, Arizona, 1993

Jeremy Huesers, 10, *Donovan*, Taos Pueblo, New Mexico, 1992

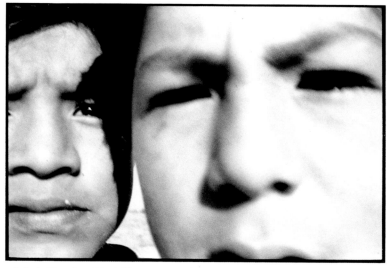

Schyle Vaughn, 10, *Self Portrait with Friend,* Peach Springs, Arizona, 1993

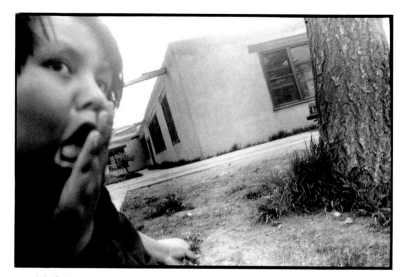

April Jiron, 11, *Boy Wiping Face,* Taos Pueblo, New Mexico, 1993

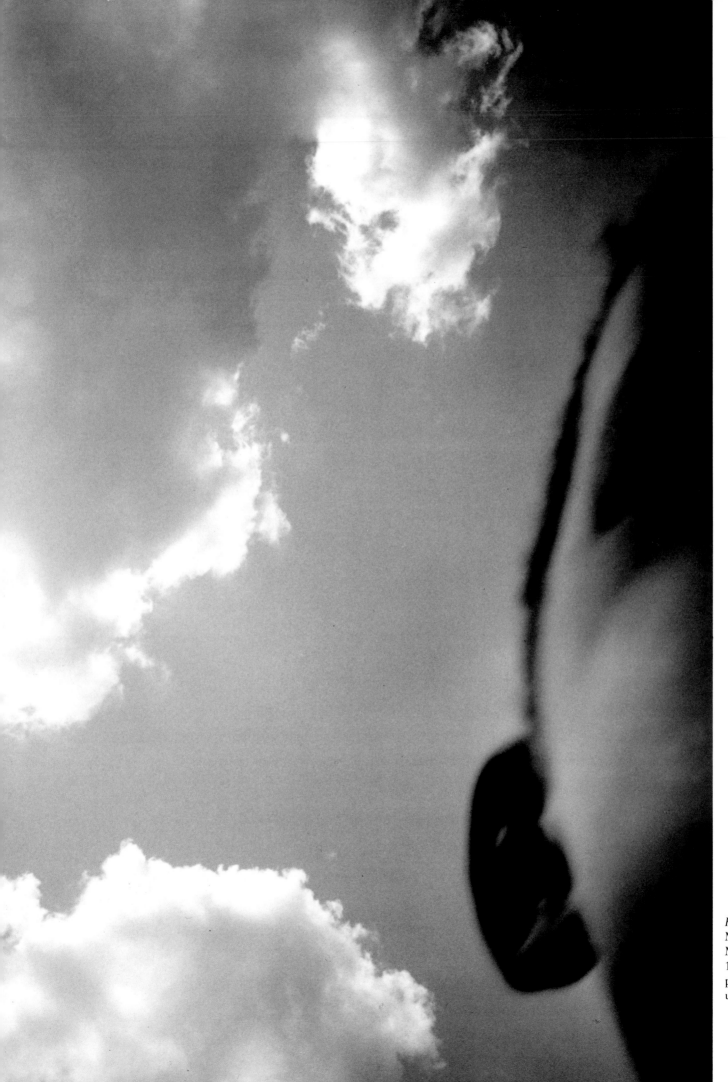

Head in Clouds,
Minneapolis,
Minnesota,
1992,
photographer
unknown

47

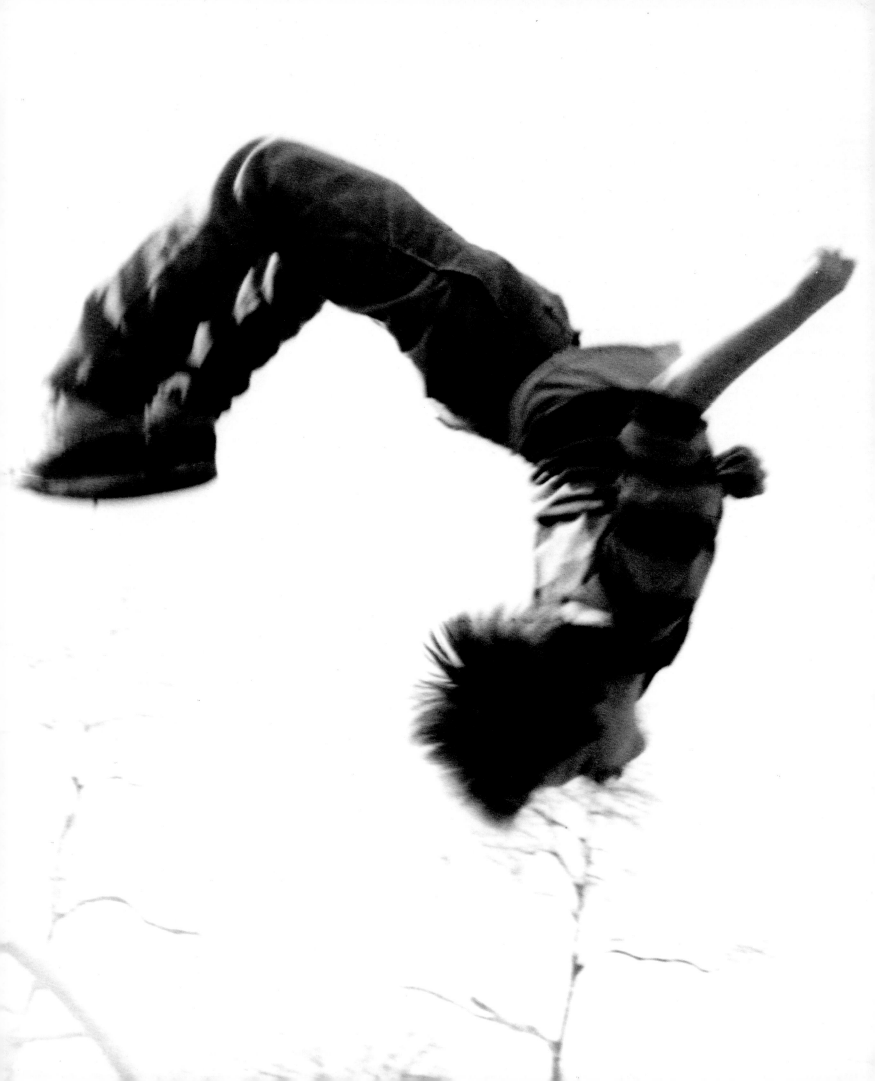

"When I pick up a camera, it feels like I'm going to a different dimension. I like to take pictures of good things, in all kinds of ways."

"What dimension do you go to?"

"The future."

—RONALD LEWIS, JR., 10
to Jim Hubbard,
Hualapai Reservation, Peach
Springs, Arizona 1993

Flip II, Minneapolis, Minnesota, 1992, photographer unknown

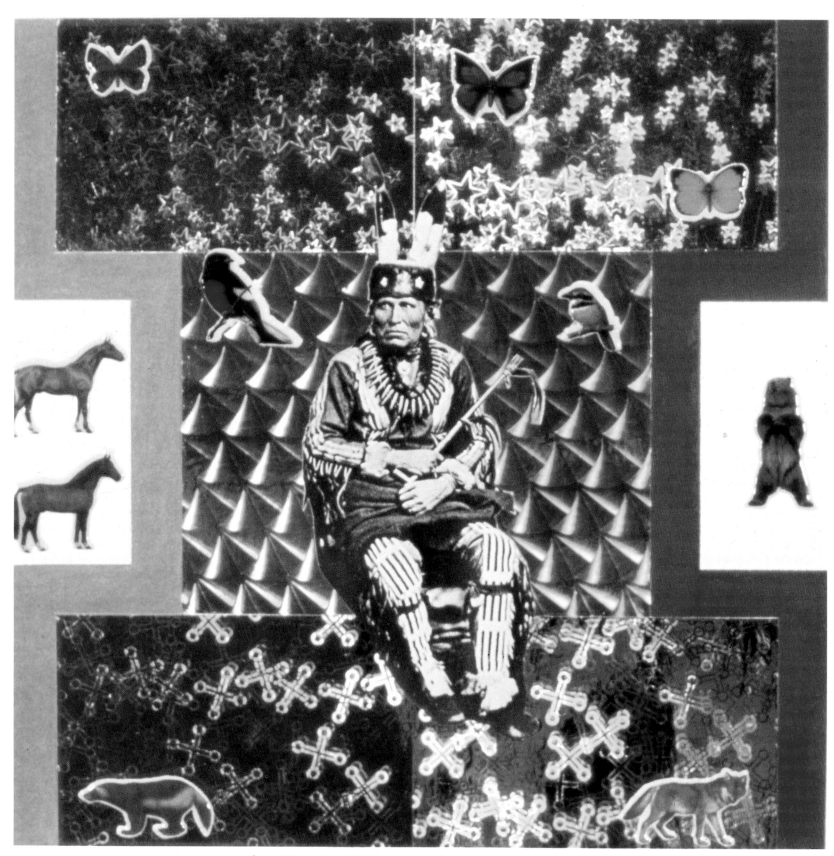

Above: George Longfish (Seneca/Tuscarora), *"I" is for Indian*, 1992
Pages 52–53: George Longfish, *America 500 Years*, 1991

SOVEREIGNTY: A LINE IN THE SAND

BY JOLENE RICKARD

PHOTOGRAPHS BY GEORGE LONGFISH

ZIG JACKSON

PAMELA SHIELDS CARROLL

RON CARRAHER

HULLEAH TSINHNAHJINNIE

On November 4, 1924, a wiry man armed with an eagle feather and a string of wampum dared to challenge the most forceful countries in the world by defining terms for indigenous survival into the twentieth century. Cayuga Chief Deskaheh presented an official proclamation from the Iroquois Confederacy to the League of Nations in Geneva, documenting our independence and sovereignty as recognized in treaties with the Dutch, British, and American governments. Sixty-four years later Stephen Cornell, in *The Return of the Native*,[1] pointed out that as late as 1800, more than 80 percent of what are now the contiguous forty-eight states was still Indian land. By the end of the nineteenth century less than 5 percent was in indigenous hands. Positioning Deskaheh's radical stance of declaring our independence and sovereignty after centuries of dispossession from our lands was like drawing a line in the sand at the ocean's edge. What purpose this line?

Sovereignty is the border that shifts indigenous experience from a victimized stance to a strategic one. The recognition of this puts brains in our heads, and muscle on our bones. Vine Deloria, in *We Talk, You Listen*,[2] placed sovereignty and power hand in hand, primarily with a view to perpetuating the existence of the group. Yet if I were to throw the term *sovereignty* out there at your basic Indian art opening, it would plummet to the floor, weighted down by ambiguity. One may wonder if the issue of sovereignty belongs in the cultural debate. I would strongly suggest that it does. David Novitz observes in *Boundaries of Art*,[3] "The boundaries that distinguish high from popular art, good from bad, and art from life or reality do not exist independently of the social concerns, interests, aspirations, and values that form part of our everyday lives." As part of an ongoing strategy for survival, the work of indigenous artists needs to be understood through the clarifying lens of sovereignty and self-determination, not just in terms of assimilation, colonization, and identity politics.

The call for sovereignty is part of my family's work; you could say I cut my political teeth early. Deskaheh passed away at my grandfather Chief Clinton Rickard's homestead soon after returning from that trip to the League of Nations. Inspired by Deskaheh's work, my grandfather Rickard formed the Indian Defense League of America (IDLA) in 1926, dedicated to obtaining justice for Indian people. Growing up, I assumed that everybody knew that Native people used a number of strategies to survive, ranging from traditional governments to spiritual political movements to advocacy movements, such as the Society of American Indians and the IDLA in the early 1900s. Most of us are descendants of one strategy or another. And when we come across one another, our discussions are about how our people avoided extinction. It's still how people talk in our communities, mostly playing down our resistance to the state. In this sense, the state is really the entire U.S. government and in my community the last battle was last week.

By the turn of the century, devastated by artillery and germ warfare, indigenous nations shifted shape by taking legal action, sparked by the Citizen Act of 1924, or what legal scholars R. L. Barsh and James Youngblood Henderson described in *The Road*[4] as "a great experiment in coercive civilization." This act was viewed as the first step toward taxation and the loss of our political and territorial sovereignty. It was this final clip at the eagle's wing that became the inspiration for sovereignty in the early twentieth century.

Today, sovereignty is taking shape in visual thought as indigenous artists negotiate cultural space. Unfortunately, the place where the Western-based art world permits indigenous visibility is in the narrow margin of identity politics. Or the official category of "the Other" in postmodern cultural criticism, which continues to reinforce all of the old stereotypes. The trouble with this construct is that the grooves in the collective brain are deeply scored with what Robert Berkhofer describes as "the white man's Indian." The challenge is to jump track and cut a new swath for indigenous expressions.[5]

It is not easy for America, or other nations whose identities are built on the bloody conquest of indigenous people, to rethink its internal relationships. For instance, Guntram F. A. Werther admits in *Self-Determination in Western Democracies*[6] that "current political science theories about ethno-national movements in the First World cannot account for the success of aboriginal peoples, in part

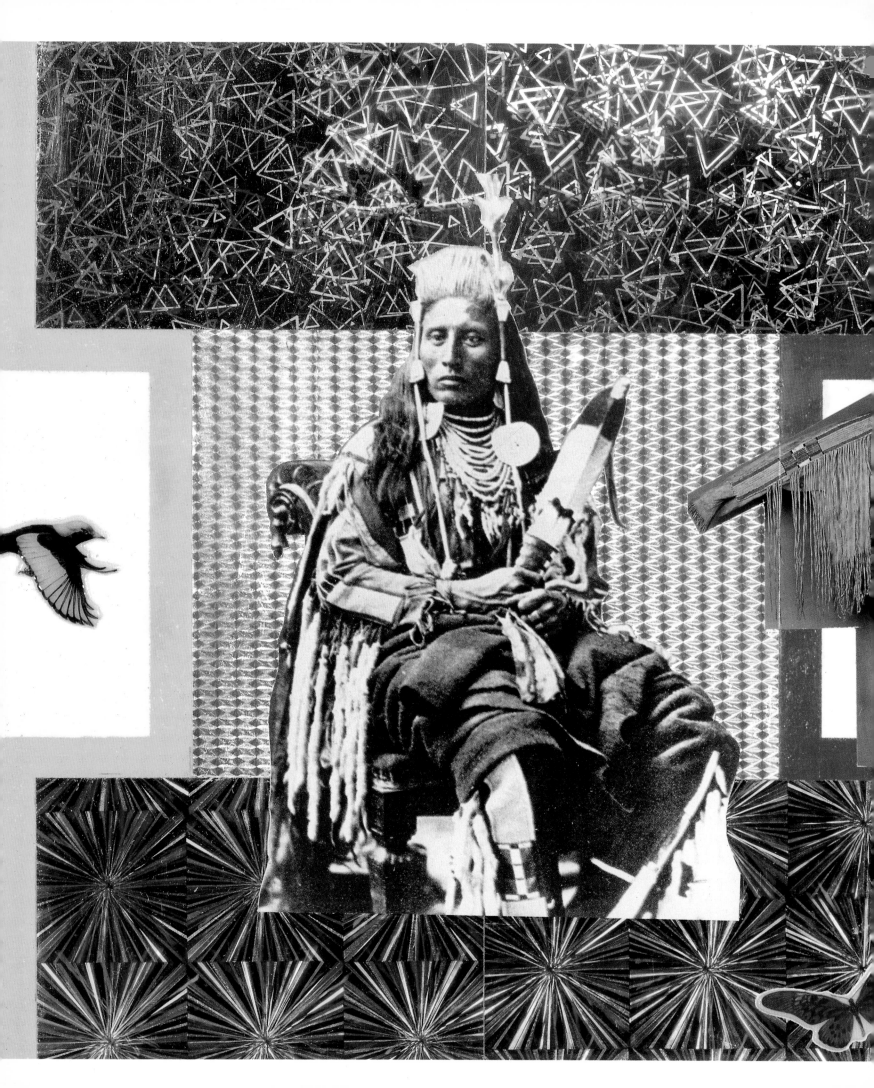

because political scientists have usually ignored aboriginal people's [political] movements." Restated, how is it that Indians slipped through the extermination net? Former president Ronald Reagan must have felt that way when, during an official visit to Moscow, he told university students "Maybe we made a mistake in trying to maintain Indian cultures. Maybe we should not have humored them in wanting to stay in that kind of primitive lifestyle." The forced expropriation of Indian lands, confinement to reservations in the 1900s, the Indian Reorganization Act (IRA) in the 1930s to the late '40s, followed by the termination period from the 1940s to the '60s —that's what all this represents—*humoring*. Reagan's perspective is just a continuation of policy established by the U.S. government in the 1800s. What can indigenous people expect when most non-Native people haven't a clue about their own history, let alone ours?

The tendency to link identity construction to sovereignty is fair. What isn't fair is the current dissection of indigenous identity issues without any historical context. Further, it's a chilling irony that dialogue in the cultural apron has stagnated on identity construction. Projecting Indians either as a reflection of the natural "childlike" state of humankind, or as tax bandits hiding behind treaty loopholes, becomes just a new twist on misrepresentation. Gerald Vizenor's claim in *Manifest Manners*[7] that representations of Native Americans establish false notions of Indianness to serve as an idealized innocence for the West, elides and eliminates the realities of tribal cultures. It's that invented simulation of Indianness that haunts photographic memories. Our artistic/cultural guideposts are lined up in galleries as continued reflections of the West. It is questionable whether non-Native people may fully understand photographs made by Indians, because it would require an ideological power shift.

For instance, is Larry McNeil's image of an eagle feather braced against the sky really Deskaheh pushing our ideas into the twenty-first century? Or is it just another easy-to-recognize Indian cultural symbol that is hip, but void of power? Same case with Zig Jackson's recent "Indian Man in San Francisco" relocation parody. Is it Indian-out-of-hegemony-synch, insisting upon a feather fashion statement or is it about the lack of acceptance, or space, in this society for difference? Hulleah Tsinhnahjinnie photochemically burned U.S.-issue identity numbers into her face, dulling full blood-brother's and -sister's radical edge, in the *Nighthawk Series*, making identity political. Do George Longfish's iconographic Indians in *America 500* represent the total embodiment of power—even suggesting some form of transformation—or subjugate soul-theft portraiture? Or, in the end, is all of this work about shifting states of reality?

Longfish's silhouetted, photographically installed Indian is transformed by gradations of color. Fixed realities and unchanging worlds are no longer accepted by leading physicists like David Bohm and F. David Peat. In *Lighting the Seventh Fire*,[8] Peat identifies Bohm's hidden dimensions of the universe as "implicate," or enfolded, order, in which the interconnections of the whole have nothing to do with locality in space and time, but exhibit an entirely different quality sometimes expressed as "unbroken wholeness." To suggest that indigenous perceptions of the laws of nature are

beginning to emerge in Western science is not to validate Longfish's knowledge; it is to acknowledge it. For indigenous people, the political border of sovereignty has sheltered the primary paradigm of indigenous thought, and Longfish is documenting that space.

His work is parallel to another idea in physics, which acknowledges that the electron's continuous exchange of energy with the universe means that it can never be isolated as an independent entity. Just as indigenous science teaches that all things connect and everything is relational, so it is with the electron's relationship to the entire cosmos. The overlapping unity in Longfish's work has a purpose, it is not simply a modernist aesthetic convention. Because duality and binaries have come to be expected from indigenous artists, Longfish's work could be read as good versus bad, or reality versus imagined Indians. But I think he is setting up a more complex discussion about life, death, and rebirth.

Essentially, Peat and Bohm suggest that the true meaning of creativity depends on understanding the whole nature of order, going beyond the confines of physics—even science—to deal with the question of society and human consciousness. Longfish's patterns viscerally map that understanding from the Western sphere to the indigenous, locating the journey to the center of the universe as being within the individual. The work of Longfish, Peat, and Bohm requires the mind to move into the middle ground between extremes. Like Longfish, the physicists recognize that creative intelligence may be regarded quite generally as the ability to perceive new categories and new orders between the older ones— in this case, disjointed extremes of the Western/non-Western dichotomy we are struggling to discard.

Photographs made by indigenous makers are the documentation of our sovereignty, both politically and spiritually. Some stick close to the spiritual centers while others break geographic and ideological rank and head West. But the images are all connected, circling in ever-sprawling spirals the terms of our experiences as human beings. The line drawn in the sand by people like Deskaheh was never simply a geographic or political mark. It has always been a taunt—an ancient lure hooking memories through time—shifting the way we see our lives. Photographs are just the latest lure.

1. Stephen Cornell, *The Return of the Native: American Indian Political Resurgence* (New York: Oxford University Press, 1988), p. 34.
2. Vine Deloria, Jr., *We Talk, You Listen,* (New York: The Macmillan Company, 1970), p. 123.
3. David Novitz, *The Boundaries of Art* (Philadelphia: Temple University Press, 1992), p. 85.
4. Russell Lawrence Barsh and James Youngblood Henderson, *The Road* (Berkeley: University of California Press, California, 1980), p. 97.
5. Robert Berkhofer, Jr. *The White Man's Indian; Images of the American Indian from Columbus to the Present* (New York: First Vintage Books Edition, A Division of Random House, 1979).
6. Guntram F. A. Werther, *Self-determination in Western Democracy: Aboriginal Politics in a Comparative Perspective* (Westport, CT. and London: Greenwood Press, 1992), p. xv.
7. Gerald Vizenor, *Manifest Manners: Postindian Warriors of Survivance* (Hanover and London: Wesleyan University Press, University Press of New England, 1994), back cover.
8. David F. Peat, *Lighting the Seventh Fire: Spiritual Ways, Healing and Science of the Native American,* (New York: Birch Lane Press, 1994), p. 284.

Zig Jackson, from the "Spirit" series, 1989

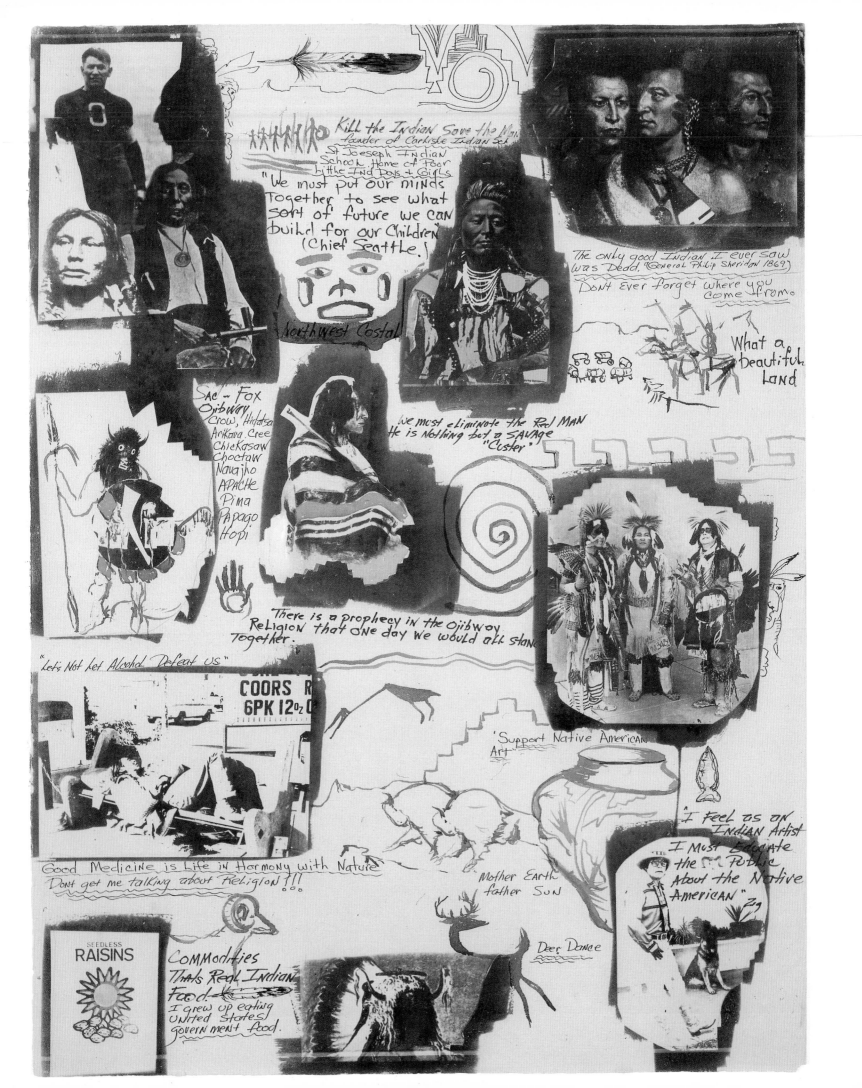

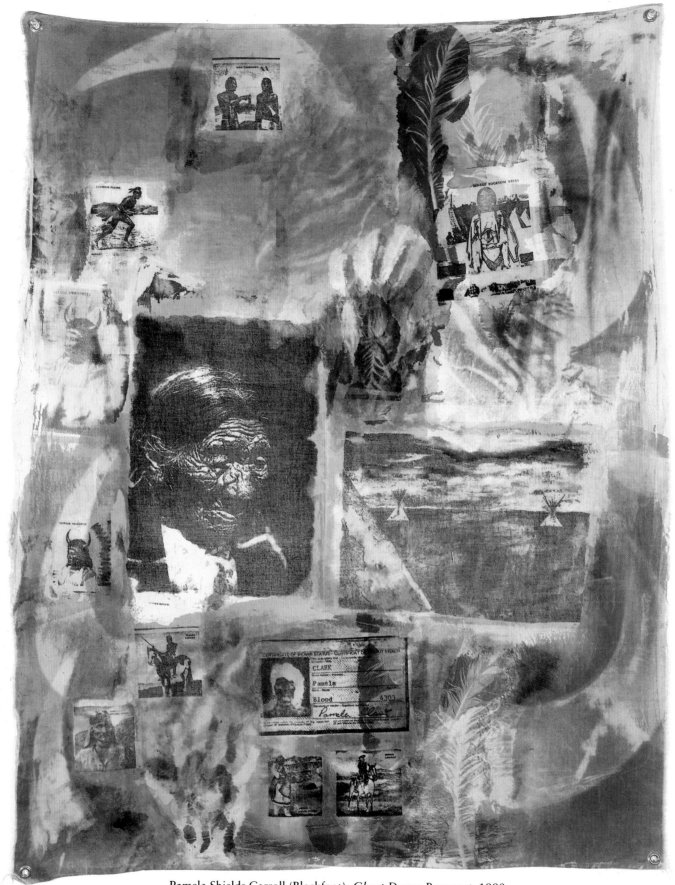

Pamela Shields Carroll (Blackfoot), *Ghost Dance Remnant*, 1990

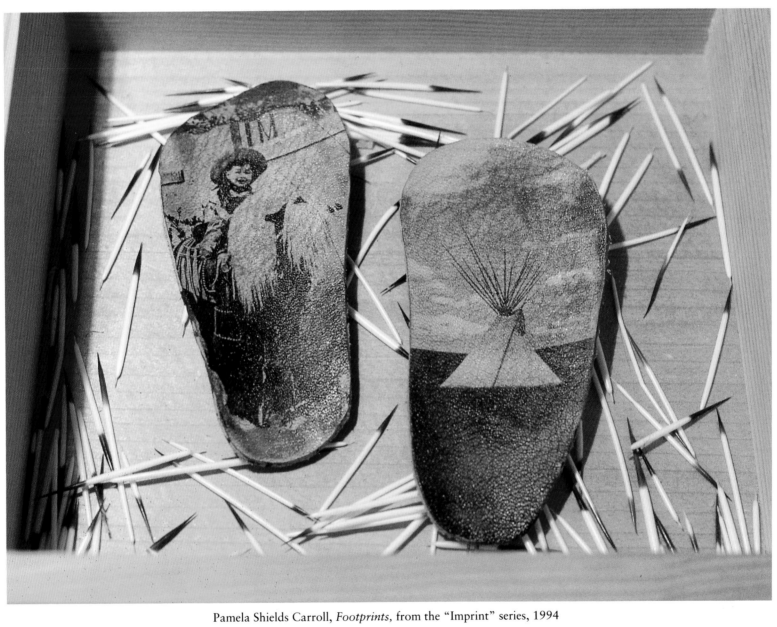

Pamela Shields Carroll, *Footprints*, from the "Imprint" series, 1994

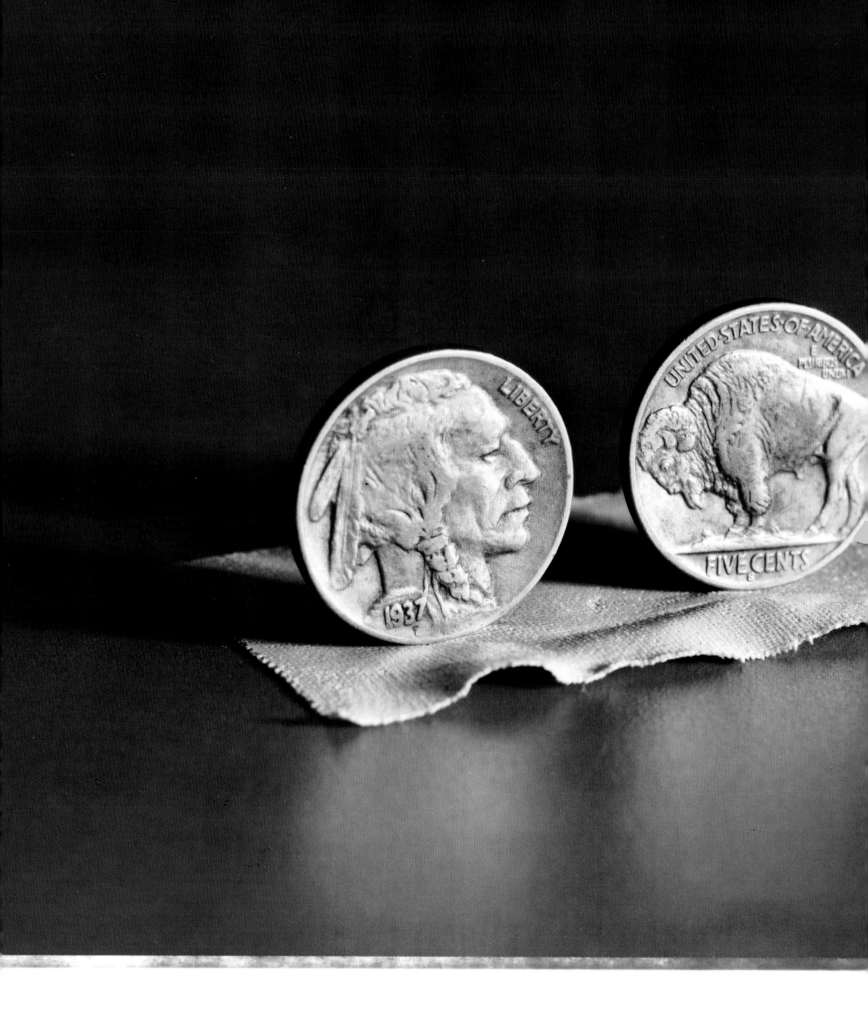

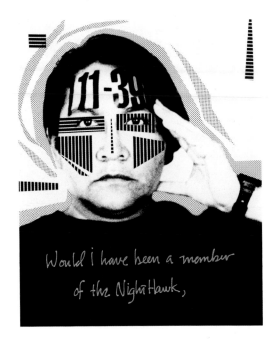

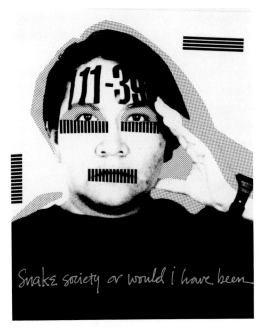

Left:
Ron Carraher
(Colville Confederated Tribes),
Native Nickels, 1992

Right:
Hulleah Tsinhnahjinnie
(Navajo/Creek/Seminole),
*Would I Have Been a
Member of the Nighthawk,
Snake Society or
Would I Have Been a Half-
Breed Leading the Whites to
the Full-Bloods*, 1991

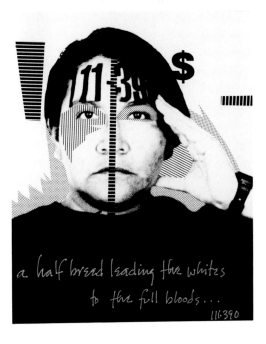

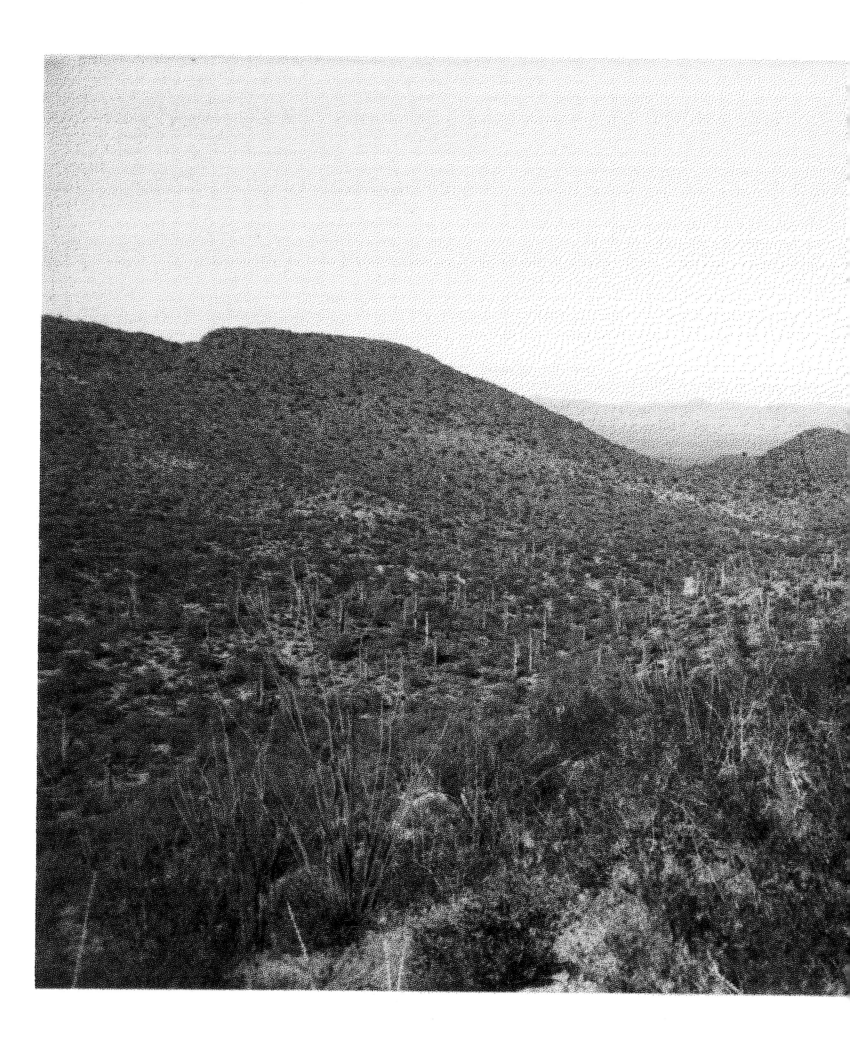

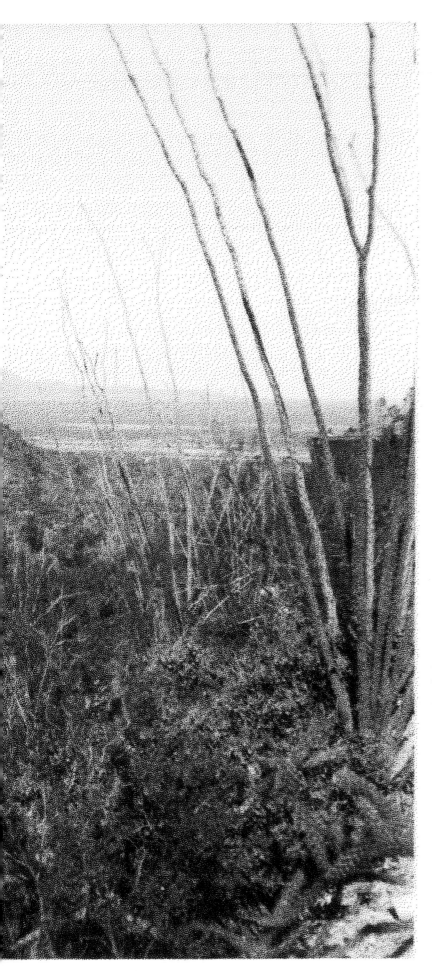

AN ESSAY ON ROCKS

PHOTOGRAPHS AND TEXT BY

LESLIE MARMON SILKO

From the top of the ridge I can see off in the distance a black form against the white arroyo sand. The first time I noticed it, my curiosity was aroused. I thought it had to be something—a blackened carcass or a large safe half-buried in the sand. Some days it appears to be the head of a horse, and other times it looks like a steamer trunk of black tin.

The arroyo descends through black basalt and pale ridges of crumbling volcanic tuff that are thick with jade-green *palo verde* and giant saguaro that thrive where the ancient volcano exploded. The violence of the explosion destroyed the volcano, and all that remains are these weathered cone-shaped hills of dark lava and basalt layered with pale ash. In the explosions, great fiery gaseous clouds sucked up pebbles and stones and melted them into strange glassy rocks with colorful swirls and patterns of stars.

After I leave the top of the ridge, I can no longer
see the black object, only glimpses of the white sand of the arroyo
snaking through the dark-green thickets and black basalt. From time
to time as I walk down the ridge through the *palo verde* and jojoba
thicket, I try to locate the black object in the wash; but it can only be
seen from the top of the ridge.

I make my way through the bright green catsclaw and the
leafy mesquites that border the wash, and as I get closer I try to antic-
ipate what I will find. These lava hills northwest of Tucson are full of
secrets. Loot from the last train robbery in 1917 was carried to these
hills. Bootleggers brewed sour mash in the old mine shafts to avoid
detection during Prohibition; rusty hoops from oak barrels are all that
remain. Duffle bags full of cash and cocaine are heaved out of air-
planes in the middle of the night. Kidnappers scrape out shallow
graves in the gravel; they cover their victims with dry weeds and
debris; in time, the desert spiders spin thick webs over the weeds.

The palms of my hands are wet with anticipation. I glance
over my shoulder from time to time to get my bearings from the top
of the ridge. I must be almost there, I think. My alignment with the
ridge is perfect.

I have watched the black form from the top of the ridge for months; still, what I see now seems much too small to be the black object I've been watching. Yet I am aligned with the ridge; this is the place. It is only a black rock the size of an auto engine alone in the middle of the arroyo half-buried in the white sand. When it rains, the runoff water parts to flow around the black rock on either side. A small, umbrella-shaped mesquite tree grows beside the black rock.

Observed up close, the rock has a smooth metallic luster sometimes found on meteorites. It is a rock with the peculiar property of appearing larger at a distance, and smaller when seen close up. Those who pay no attention to rocks may be surprised, but the appearance of a rock may change from hour to hour. Some attribute the changes to the angle of the sun or the shift in shadows on the snow next to the rock. Once while I was deer-hunting I saw a giant bear sleeping on a rock in the sun; when I got closer there was only the great basalt boulder amid the patches of melting snow.

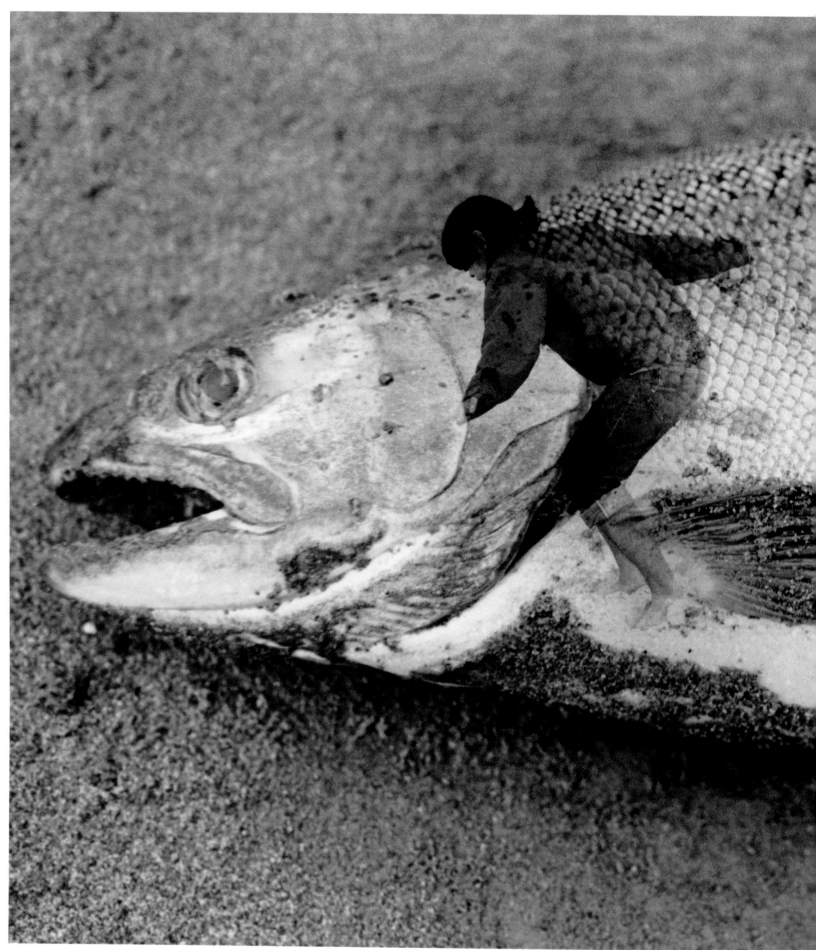

CARRY

BY LINDA HOGAN

From water's broken mirror
we pulled it,
alive and shining,
gasping the painful other element of air.
It was not just fish.
There was more.
It was hawk, once wild with
hunger, sharp talons
locked into the dying twist
and scale of fish,
its long bones trailing like a ghost
behind fins
through the dark, cold water.

It was beautiful, that water
like a silver coin scratched thin
enough to feed us all,
smooth as skin before anyone knew
the undertow's rough hands
lived inside it, working everything down
to its absence,
and water is never lonely,
it holds so many.
It says, come close, you who want to
 swallow me,
already I am part of you.
Come near. I will shape myself around you
so soft, so calm
I will carry you
down to a world you never knew or dreamed,
I will gather you
into the hands of something stronger,
older, deeper.

Jolene Rickard (Tuscarora), *Sweka and PCB's*, 1986

Pages 66–67: Patricia Deadman (Tuscarora), from the "Beyond Saddleback" series, 1991

All the warm nights / sleep in the moonlight

Keep letting it go into you / do this all your life

do this / and you will shine outward / in old age

the moon will think / you are the moon.

TRADITIONAL SWAMPY CREE POEM

RAISIN EYES

BY LUCI TAPAHONSO

I saw my friend Ella
with a tall cowboy at the store
the other day in Shiprock.

Later, I asked her,
Who's that guy anyway?

Oh, Luci, she said (I knew what was coming),
it's terrible. He lives with me
and my money and my car.
But just for a while.
He's in AIRCA and rodeos a lot.
 And I still work.

This rodeo business is getting to me, you know,
and I'm going to leave him.
Because I think all this I'm doing now
will pay off better somewhere else,
but I just stay with him and it's hard
because
 he just smiles that way, you know,
 and then I end up paying entry fees
 and putting shiny Tony Lamas on lay-away again.
 It's not hard.

But he doesn't know when
I'll leave him and I'll drive across the flat desert
from Red Valley in blue morning light
straight to Shiprock so easily.

And anyway, my car is already used
to humming a mourning song with Gary Stewart,
complaining again of aching and breaking,
down-and-out love affairs.

Damn.
These Navajo cowboys with raisin eyes
and pointed boots are just bad news,
but it's so hard to remember that all the time,
she said with a little laugh.

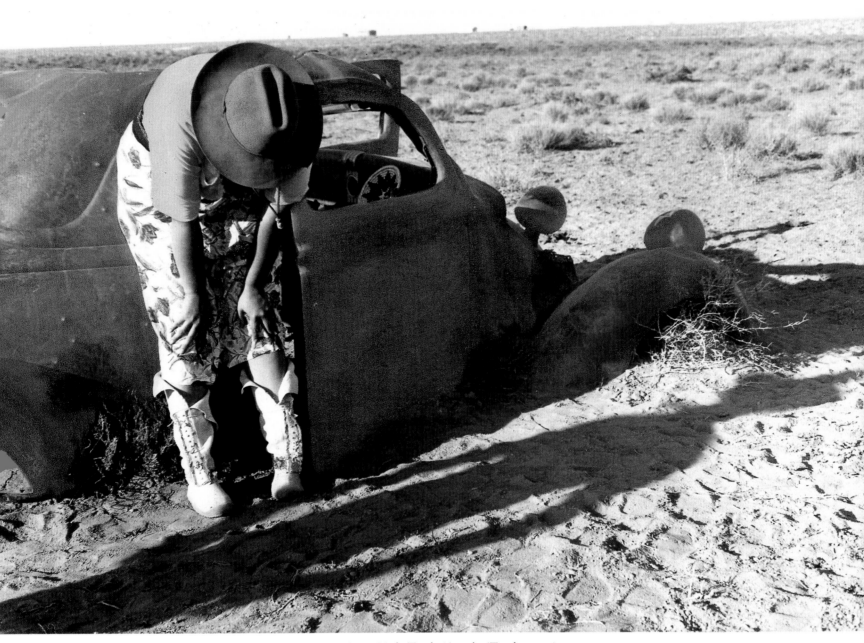

Pages 69–72: Carm Little Turtle (Apache/Tarahumara),
from the "She Wished for a Husband, Two Horses, and Many Cows" series, 1989

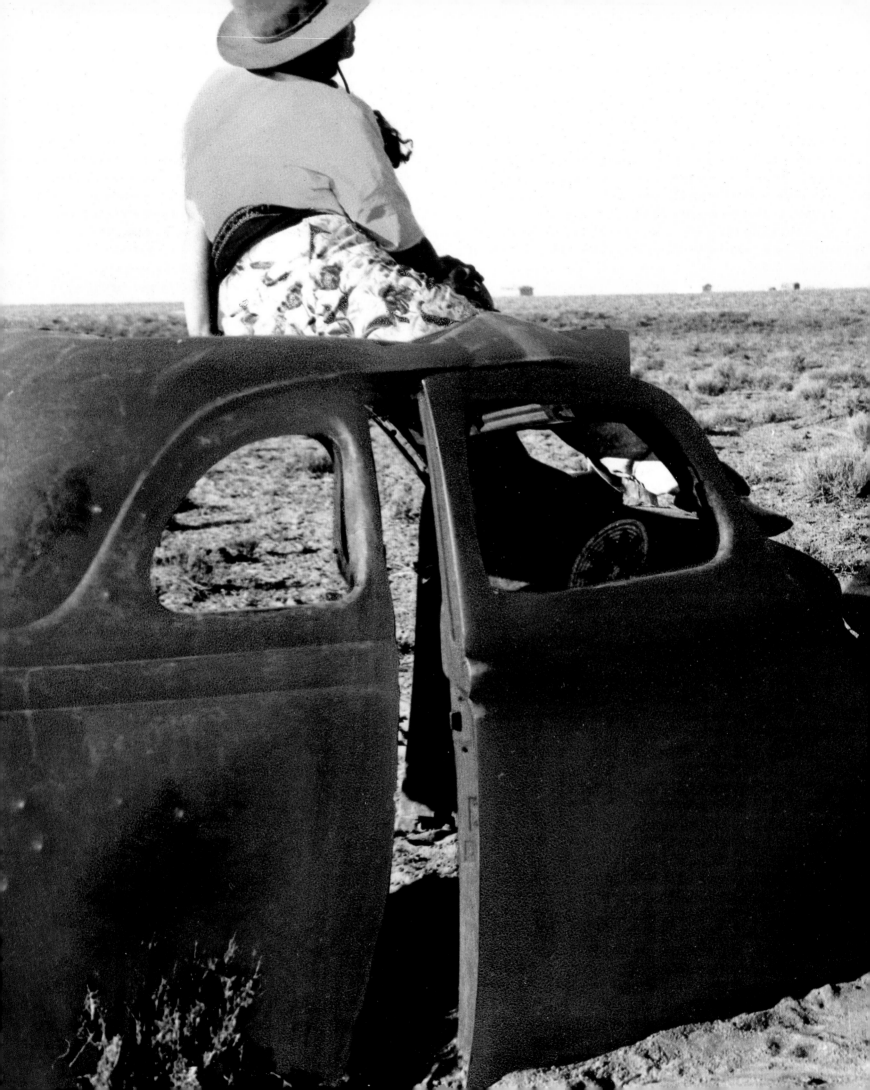

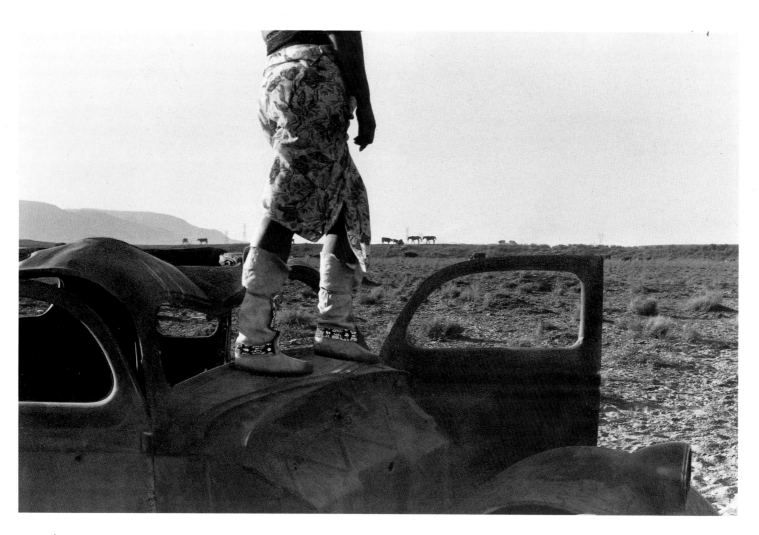

Daydreamer,
1984

73

THE FEATHER SERIES

PHOTOGRAPHS AND TEXT BY LARRY McNEIL

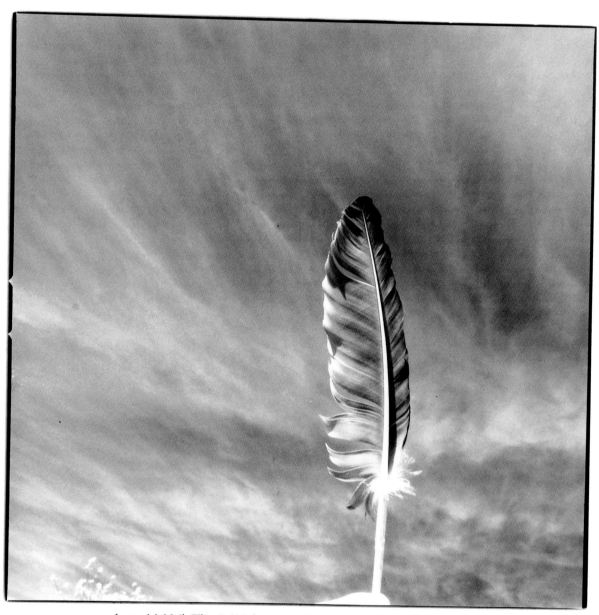

Larry McNeil (Tlingit / Nishgaa), *1491*, from the "Feather" series, 1992

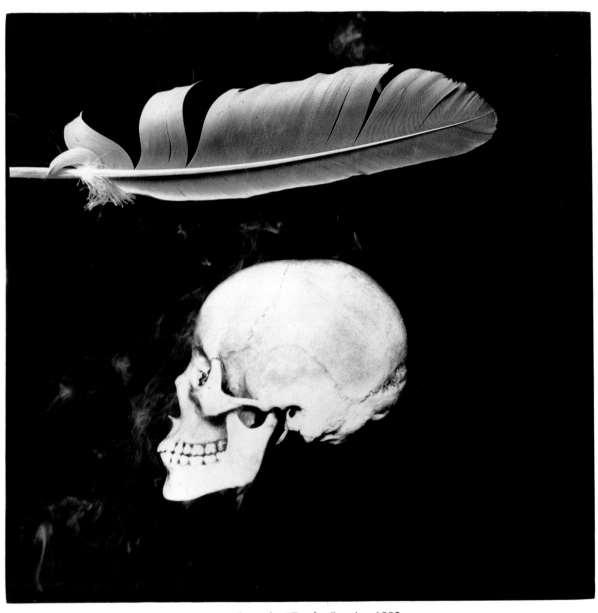

1492, from the "Feather" series, 1992

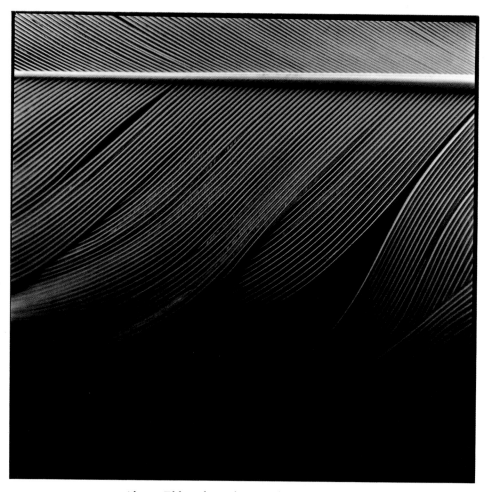

Above: *Elders*, from the "Feather" series, 1992
Below: *Circle of Rebirth*, from the "Feather" series, 1992

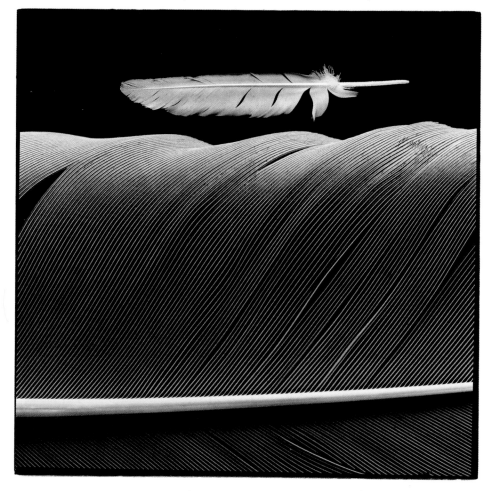

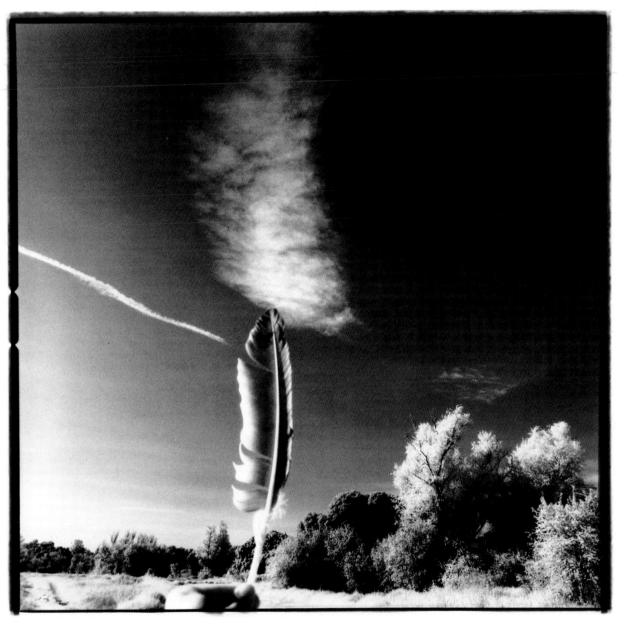

1992, from the "Feather" series, 1992

The first image in this series, 1491, symbolizes the future that never was—what would have happened had we evolved without outside interference. 1492 represents the legacy of death. Entire nations were relegated to barren, desolate regions and deprived of their livelihoods.
Our people are still dying as a consequence of their ancestors' contact with the first foreign people. Circle of Rebirth is an homage to fellow Native Americans who struggle, often against incredible odds, to maintain their identity, to continue the circle of life. 1992 represents the future denied us in 1491—a reminder that native people still have a future that we can make our own. Elders is an homage to the people who have carried the gift of tradition over the years. Our elders recognized that surviving is not enough. With love and humor, they have taught us that each individual has a responsibility to make this world a better place.

KAKE IS THE PLACE OF NO REST, IT IS

BY ROBERT DAVIS

I've heard of men in black robes who came
instructing the heathen natives:
outlaw demon shamanism,
do away with potlatch,
pagan ceremony,
totem idolatry.
Get rid of your old ways.
The people listened.

They dynamited the few Kake totems—
mortuary poles fell with bones,
clan identifiers lost in powder,
storytellers blown to pieces
settle on the new boardwalk
running along the beachfront.
Houses built off the ground now
and my aunt drove the silver spike
in the middle of Silver Street
sealing the past forever.

People began to move differently, tense.
They began to talk differently, mixed.
Acted ashamed of gunny sacks of k'ink'
and mayonnaise jars of stink eggs,
and no one mashed blueberries
with salmon eggs anymore.

People walked differently, falling all over.
A storekeeper took artifacts for credit
before his store went up in a blaze.

Grandfather went out in his slow skiff
and cached in the cliffs
his leather wrapped possessions
preserved like a shaman body
that can't be destroyed, that won't burn.

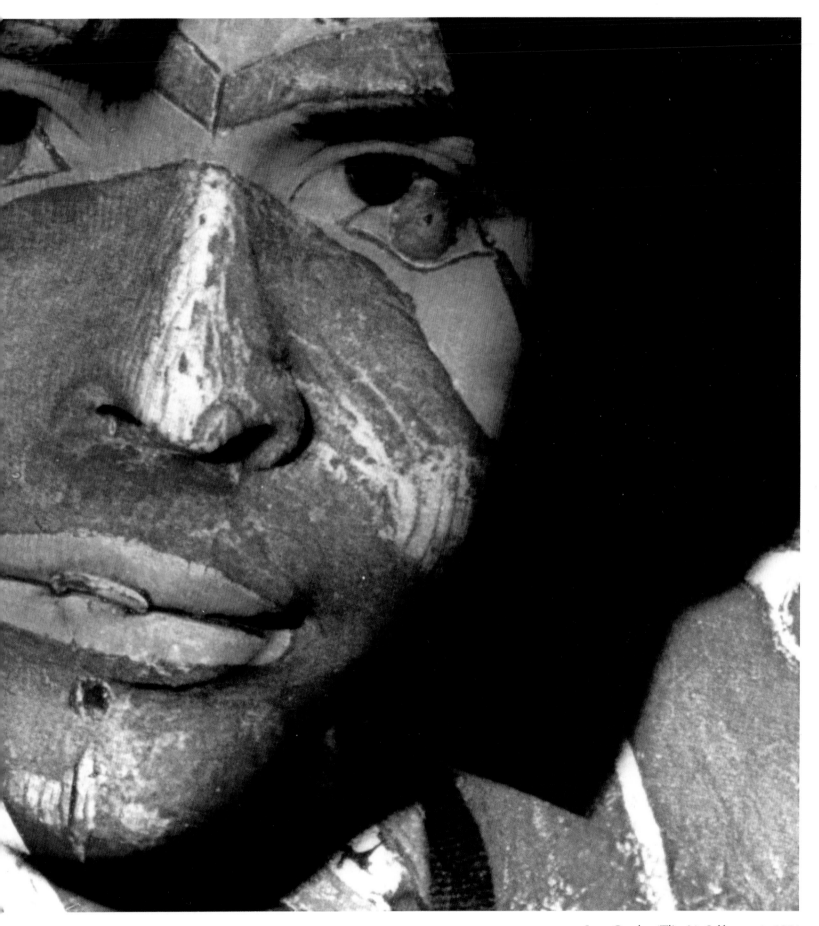

Jesse Cooday (Tlingit), *Self-portrait*, 1984

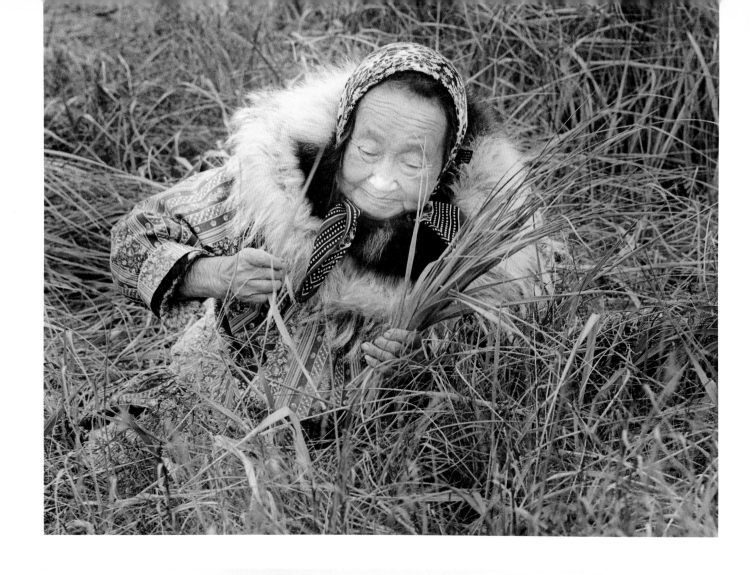

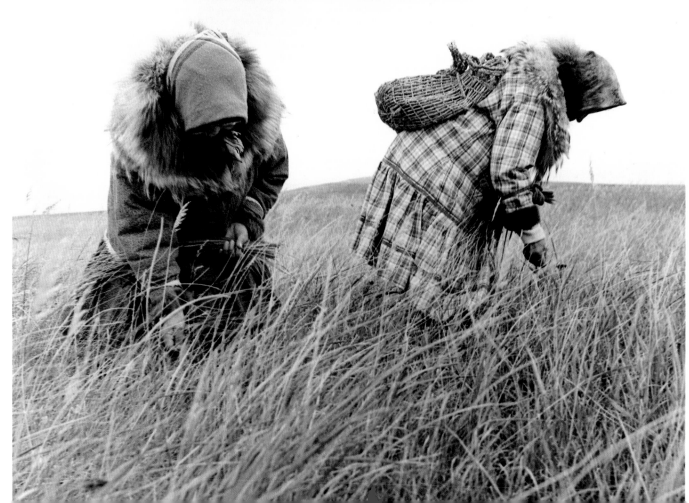

Larry McNeil
(Tlingit / Nishgaa),
*Salt Water Grass
Artists*, from the
"Yupik Ladies" series,
Alaska, 1981

THE TLINGIT NATIONAL ANTHEM

RETOLD BY ROBERT WILLARD, JR.

This is the story of the Tlingit National Anthem, a song that entwines our people with their past and keeps our ancient heritage alive. At potlatch ceremonies, Tlingit elders sing the anthem and tell how it came about—for many years in secret, for this ritual was long forbidden by the government—always passing the story on to the new generations.

Long ago, the Tlingit Indians lived in the area now called British Columbia and the Yukon Territory. They decided to move from this region of lakes to the great ocean—now called the Pacific—where they heard that the fish were abundant. When all of the clans had assembled, they began a great trek through the mountain canyons leading to the sea.

After many, many miles, the way was blocked by a glacier that filled the canyon. To go back in search of a different route would be a long and wasting journey, so the leaders climbed the mountain to look for a safe way around the ice; there was none. But they saw a stream, flowing from the narrow mouth of the glacier, which emptied into a great bay on the distant side. The passage under the glacier seemed too dangerous, the ice caverns too narrow to pass through. Determined to continue the migration to the ocean, the leaders met to plot a new course.

Then, four women stepped forward and volunteered to journey beneath the glacier. Two were barren, one was a widow, and the fourth was well along in years. Because the women had no children to nurture and protect, the leaders agreed to their risky plan. So, the men built a raft of logs and the women set forth early the next morning. With renewed hopes, the leaders once again climbed the mountain, keeping watch all morning and into the afternoon.

Toward evening, they heard distant voices calling from the bay. It was the four women, waving their arms and shouting, "We made it, we made it through, under the ice." Then, the youngest and strongest of the men set out for the other side. When they arrived, they began building large boats for the next part of the journey, and explored the region beyond the glacier for a safe place abundant in resources. Then, all of the Tlingit people followed behind them. After three days and three nights, they came safely through the ice caverns. So, they set up camps and rested.

The next day, the people asked the Spirit to be with them. They decided to row in all directions and to settle as much unoccupied territory as possible. It was a sad, sad day as the people sang good-bye to their uncles and aunts and cousins and friends. They wept as they rowed, but the song they sang has lasted all these many years. It was a sad, sad day, but it was the beginning of the Tlingit Nation, which today occupies more than twenty-three million acres of land and water in Southeast Alaska.

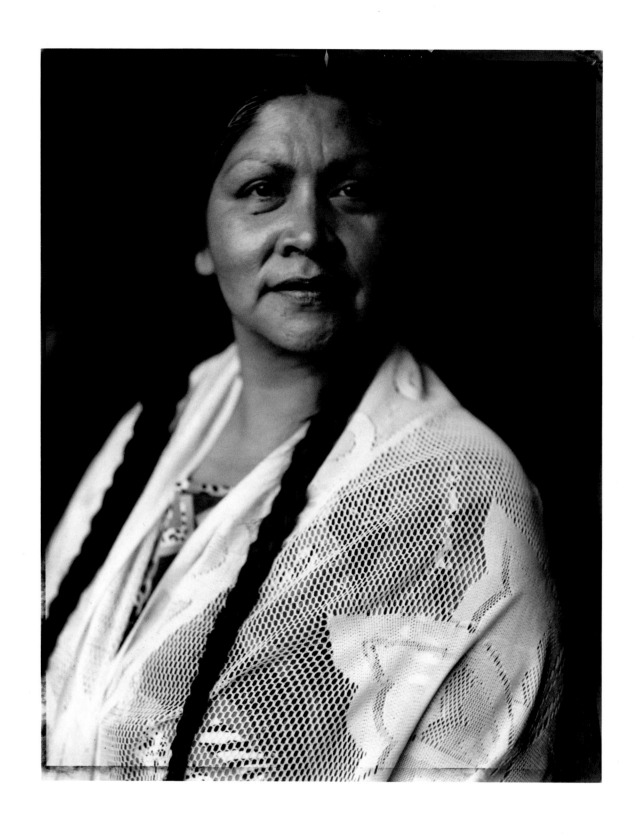

THE URBAN VILLAGE

PHOTOGRAPHS BY GREG STAATS

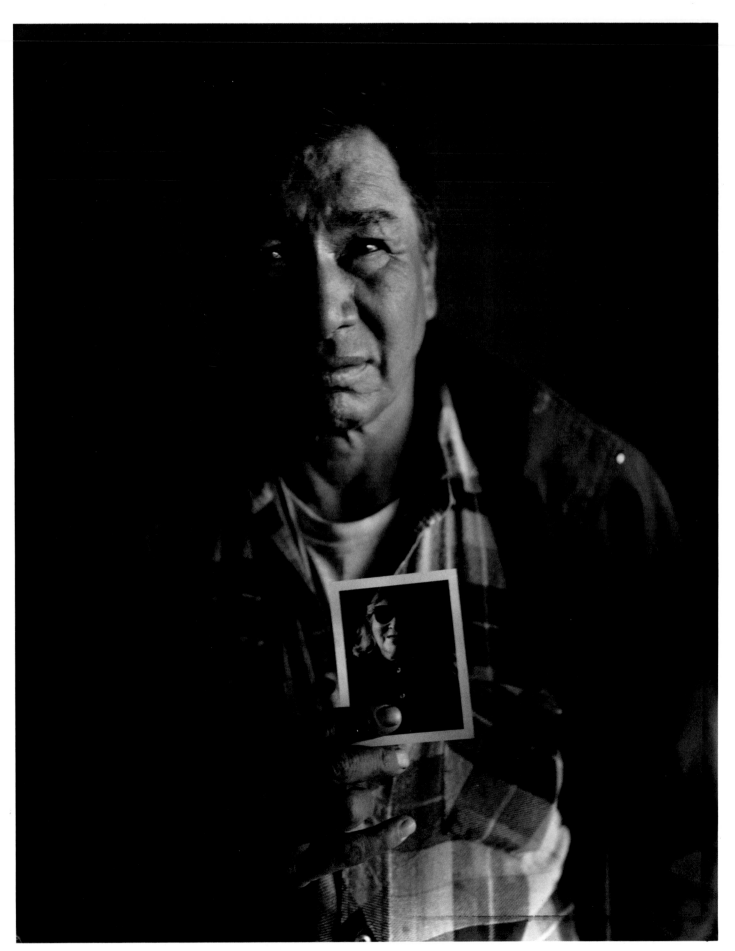

Opposite: Greg Staats (Mohawk), *Rose Hunter*, 1994. *Above: Joseph Gull*, 1994

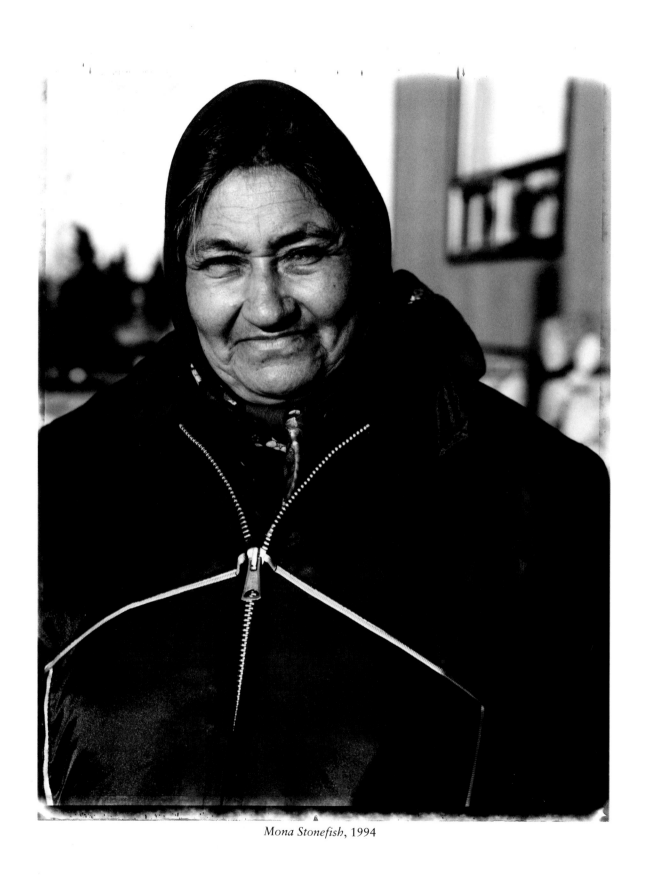

Mona Stonefish, 1994

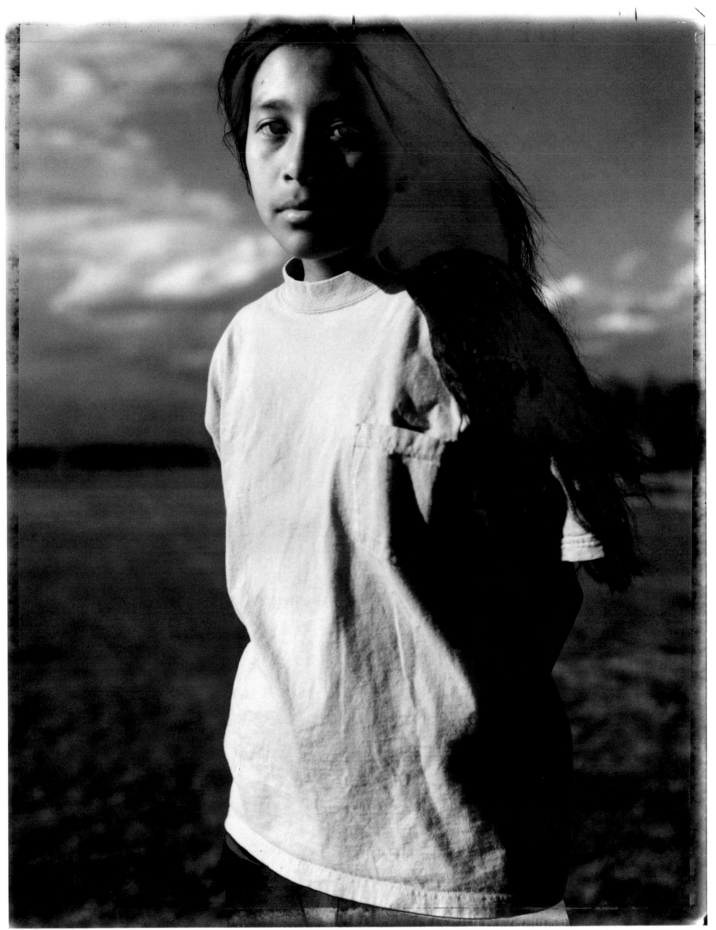

Cheyenne Ringlero, 1994

THE LAND IS OUR MOTHER

PHOTOGRAPHS AND TEXT BY NANCY ACKERMAN

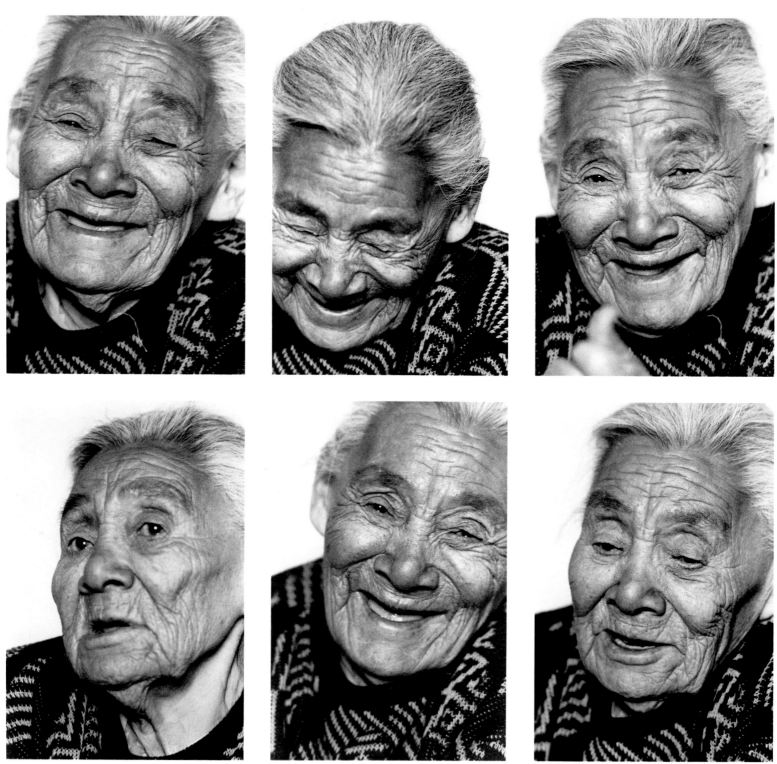

Nancy Ackerman (Mohawk ancestry), *Mina Weetaltuk*, Kujuaarapik (Great Whale), Quebec, 1992

Inuit elder and activist Mina Weetaltuk laughs as she talks about everything from growing up in northern Quebec and marrying a stranger when she was fourteen to the struggle to save her land. In 1994 the Quebec Hydro–James Bay project, which would have flooded hundreds of thousands of acres of Inuit and Cree territory, was scrapped when the government bowed to pressure by white environmentalists and Native groups such as Mina's.

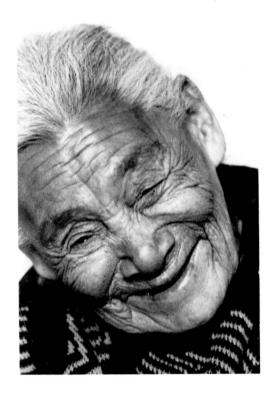 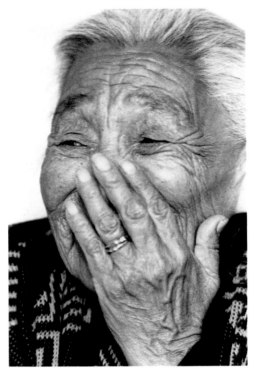 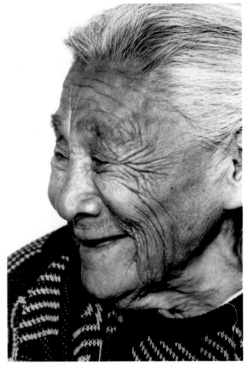

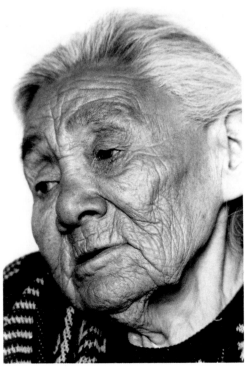 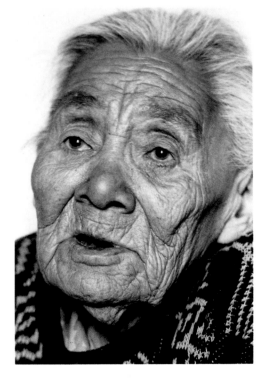 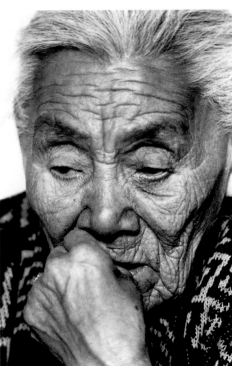

OUR CHIEFS AND ELDERS

PHOTOGRAPHS BY DAVID NEEL

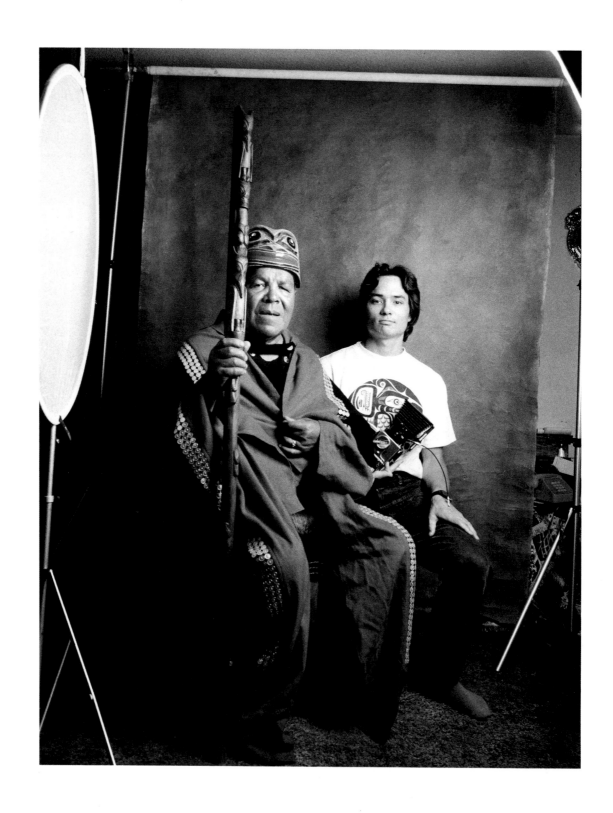

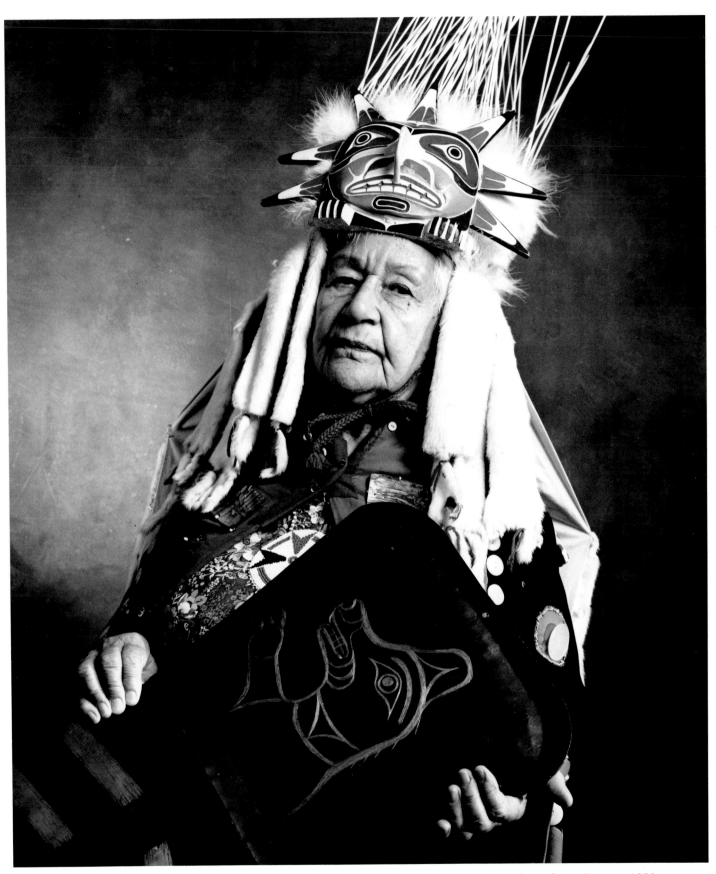

Above: David Neel (Kwagiutl), *Catherine Adams*, Gwa'sala 'Nakwaxda'xw, Gwa'sala 'Nakwaxda'xw Reserve, 1990
Opposite: *Self-portrait with Chief Charlie (James) Swanson*, Greenville, British Columbia, 1991

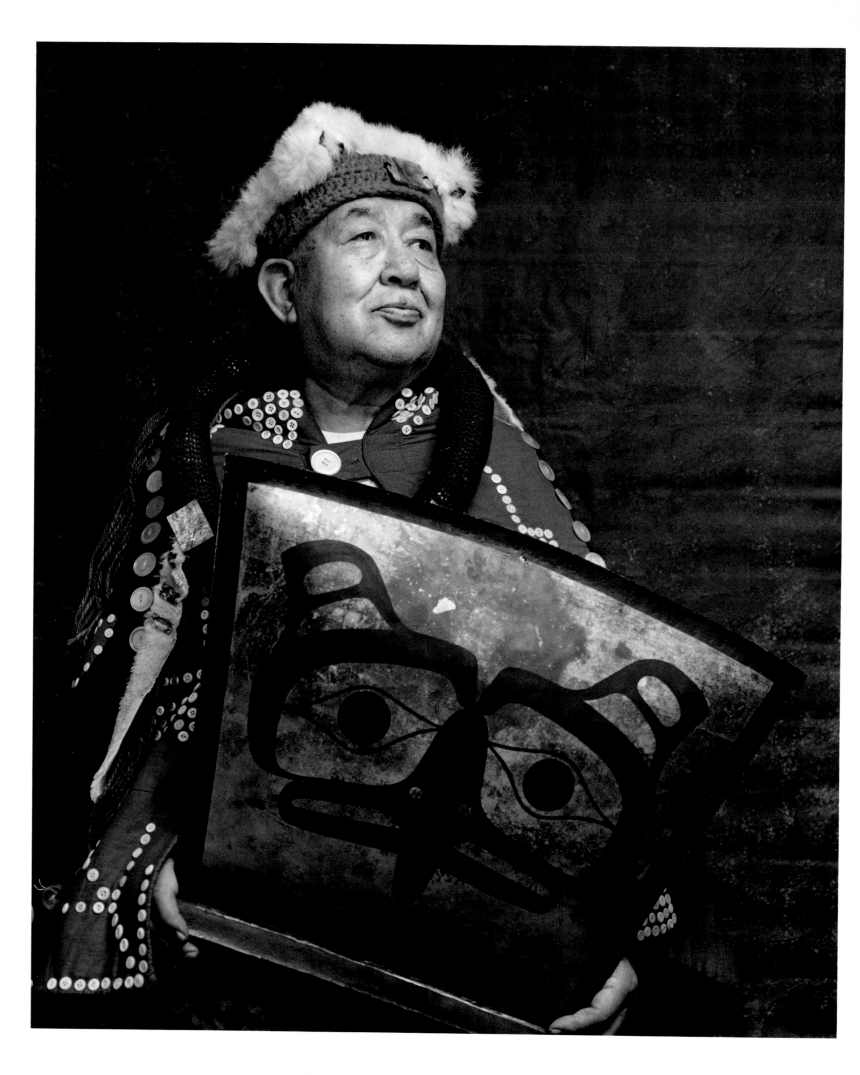

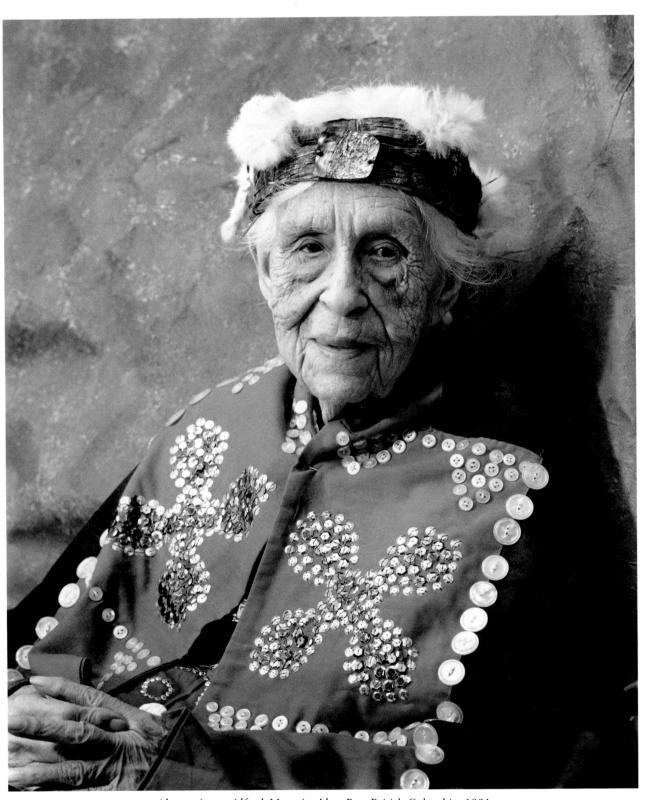

Above: *Agnes Alfred*, Namgis, Alert Bay, British Columbia, 1991
Opposite: *Chief Alvin Alfred*, Namgis, Alert Bay, British Columbia, 1990

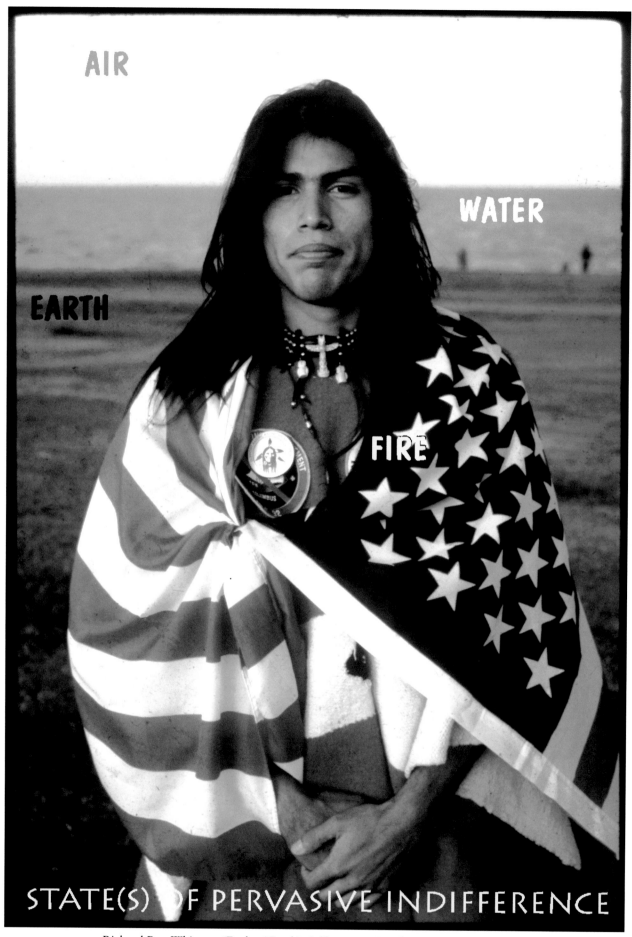

AIR

WATER

EARTH

FIRE

STATE(S) OF PERVASIVE INDIFFERENCE

Richard Ray Whitman (Euchee/Creek), *Self-portrait: Earth, Air, Fire, Water*, 1993

PLEA TO THOSE WHO MATTER

––––––––

BY JAMES WELCH

PHOTOGRAPHS BY RICHARD RAY WHITMAN

You don't know I pretend my dumb.
My songs often wise, my bells could chase
the snow across these whistle-black plains.
Celebrate. The days are grim. Call your winds
to blast these bundled streets and patronize
my past of poverty and 4-day feasts.

Don't ignore me. I'll build my face a different way,
a way to make you know that I am no longer
proud, my name not strong enough to stand alone.
If I lie and say you took me for a friend,
patched together in my thin bones,
will you help me be cunning and noisy as the wind?

I have plans to burn my drum, move out
and civilize this hair. See my nose? I smash it
straight for you. These teeth? I scrub my teeth
away with stones. I know you help me now I matter.
And I'll come to you, head down, bleeding from my smile,
happy for the snow clean hands of you, my friends.

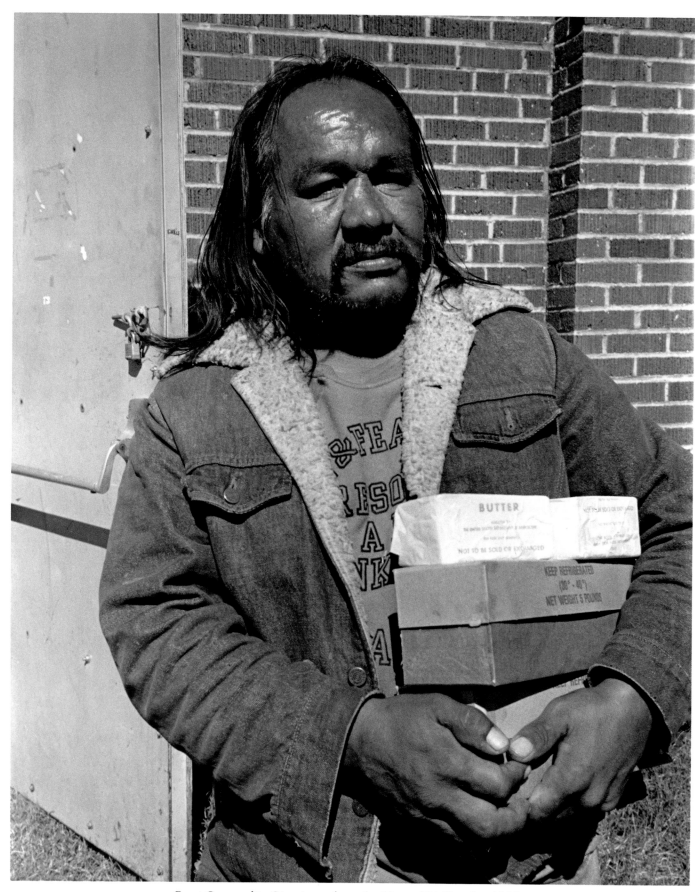

Great Commodity Give-Away, from the "Street Chief" series, 1985

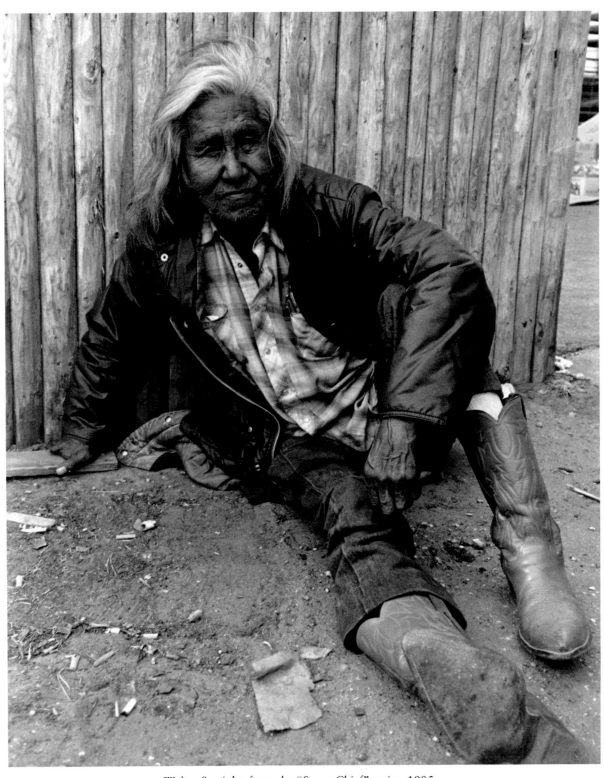

Walter Straight, from the "Street Chief" series, 1985

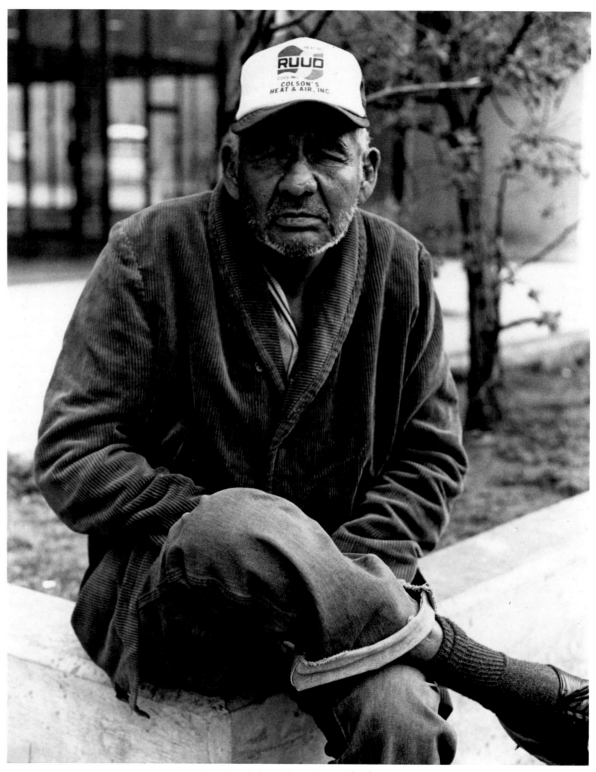

Winter in the Blood, from the "Street Chief" series, 1986

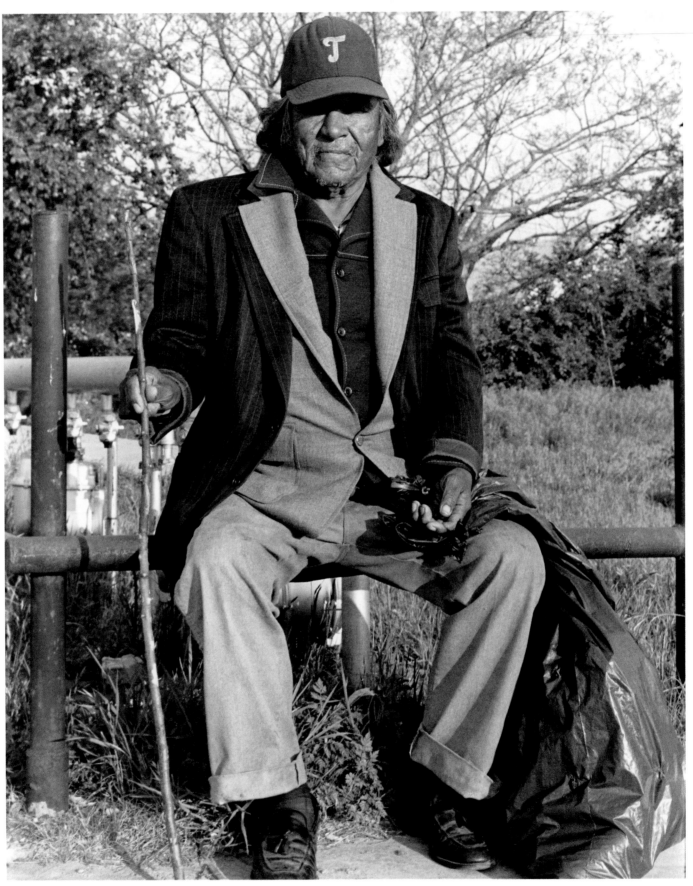

Secret Patriarch, from the "Street Chief" series, 1986

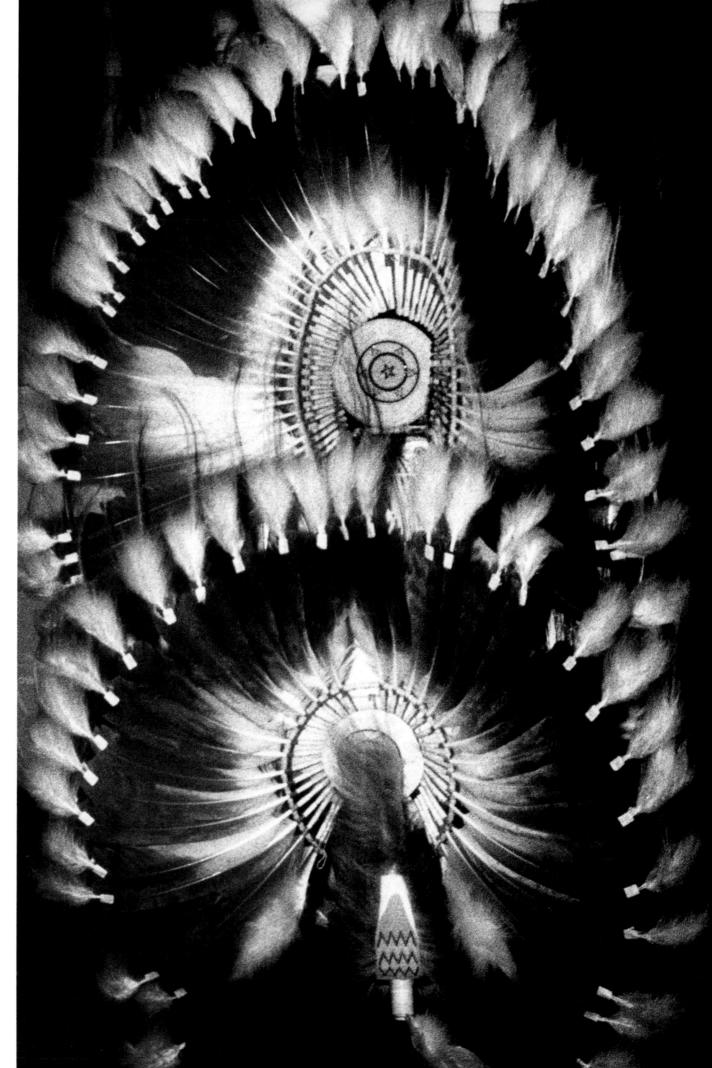

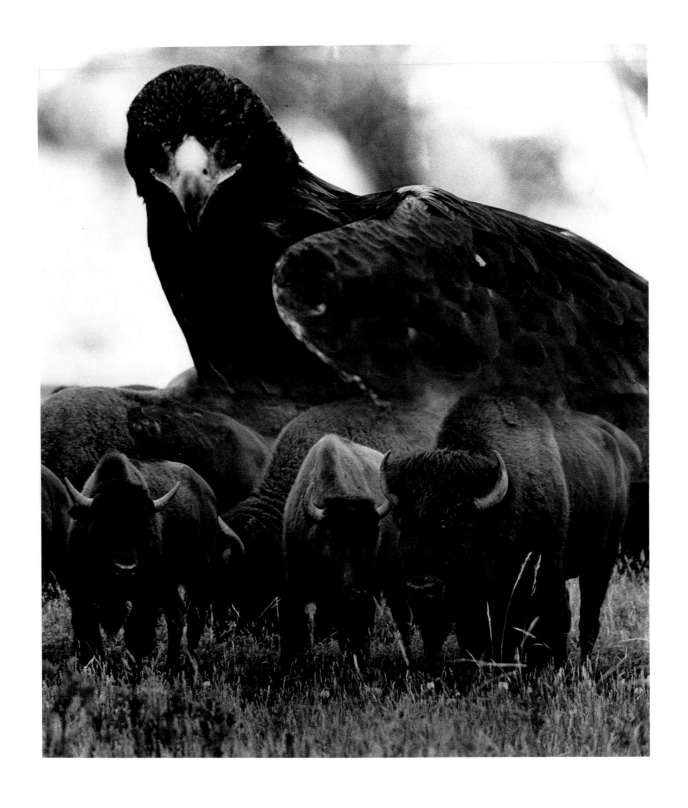

THE ORIGINAL PEOPLE

PHOTOGRAPHS BY WALTER BIGBEE

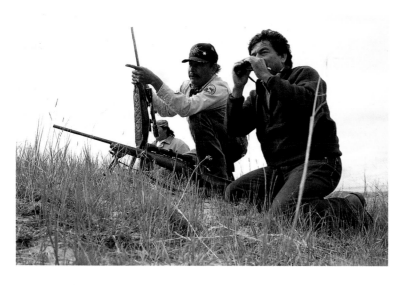
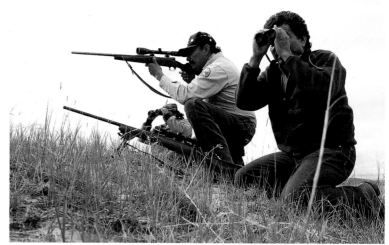

We are the sovereign and free children of Mother Earth. Since

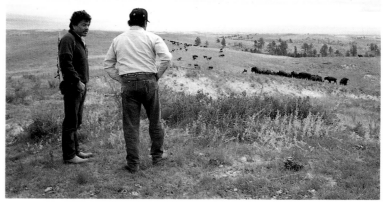

countless generations, we have lived in harmony with our relatives,

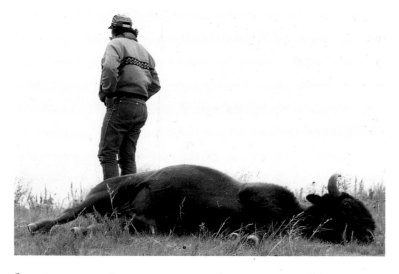
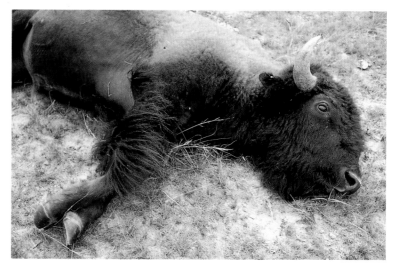

beings that crawl. For all time our home is from coast to coast,

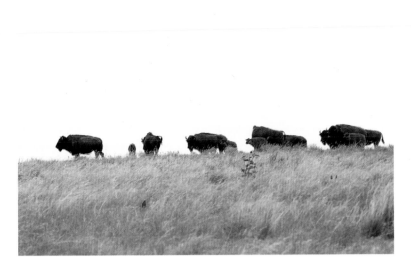 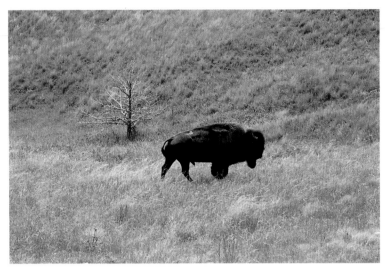

before human memory our people have lived on this land. For

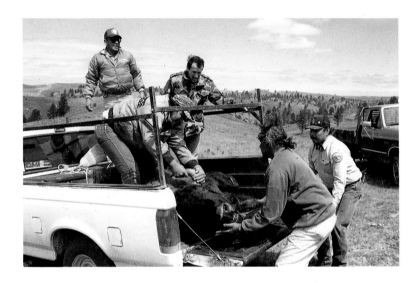 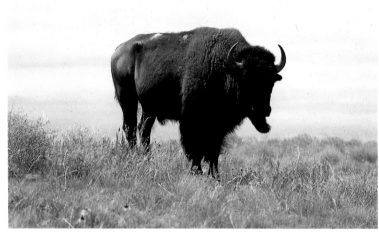

the four-leggeds, the winged beings, the beings that swim, and the

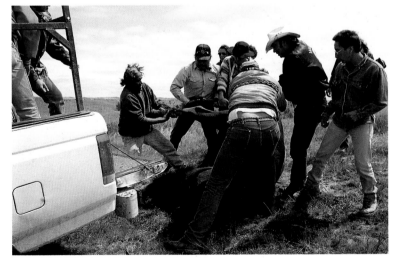 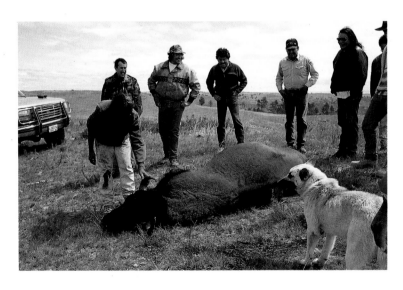

from pole to pole.

—Blackfeet Tribal Elders to U.S. Congress, 1977

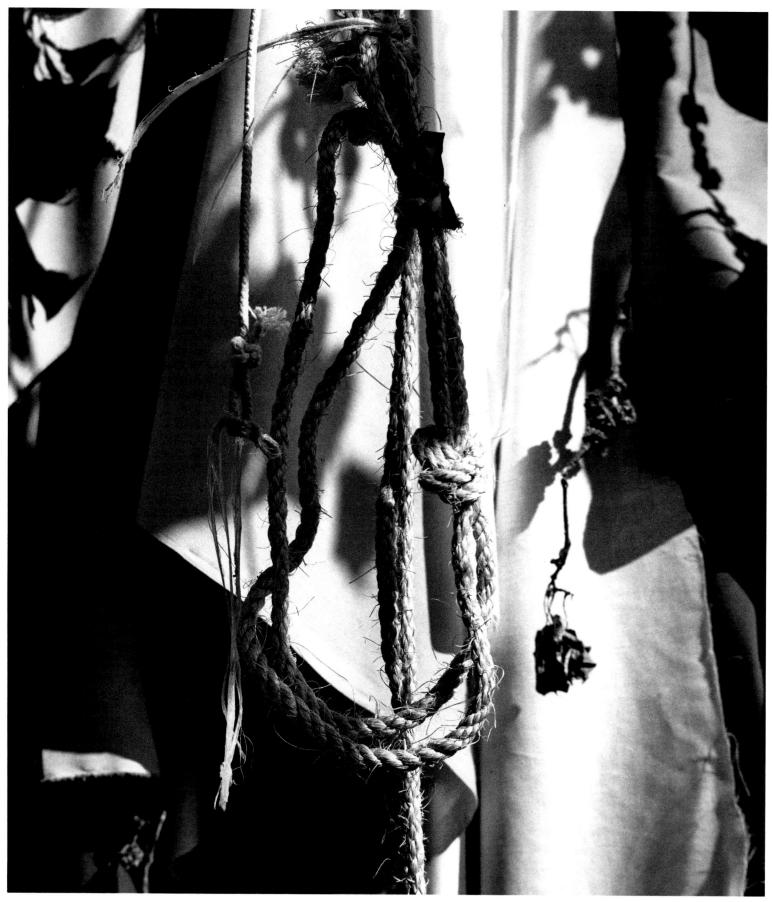

Cloth Offerings, 1991

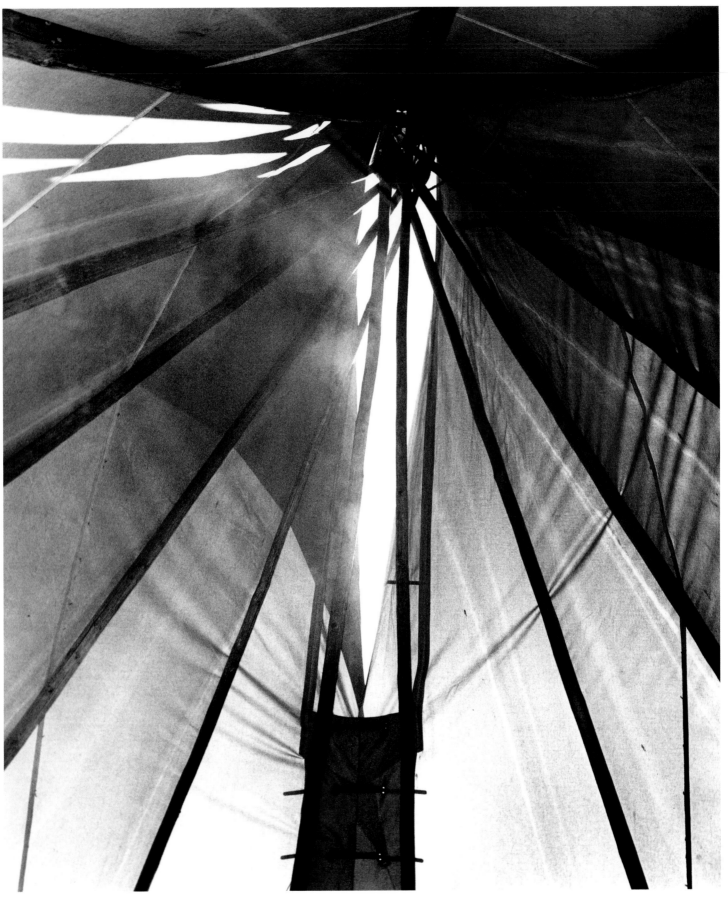

Sun Dance Tipi, 1991

STRONG HEARTS

PHOTOGRAPHS AND TEXT BY JEFFREY M. THOMAS

The romanticized American Indian warrior in full regalia, one of

the most common and anachronistic stereotypes, is best exemplified by the photographic

work of Edward S. Curtis. As portrait-sitters and performers at Wild West shows

and World Expositions, those "real Indians" were no longer human beings

but icons, symbols of a vanished race of savages. Because assimilation policies have

segregated Indians from white society so successfully, and because Indians so often are depicted

as mannequins in natural-history museums, to this day many non-Native children

believe that Indians have disappeared altogether.

These imbalances are being shifted by Native American photographers redefining their identity

from within their cultures. I have attempted to show a tradition-based reality

by confronting one of the most stereotyped images of Indians: the male powwow dancer.

The pageantry in powwow easily overshadows the origins of the regalia

and the ceremony. For example, the feather bustle (p. 108) called

"The Crow" embodies the belief that man is vitally connected with all forms of life;

that he is always in touch with the supernatural; that the life and acts of the warrior are

motivated by Thunder, the god of war. This ornament could only be worn by

a man who had already achieved great honor on the battlefield.

The Crow is an icon in the true sense, and it still retains its original meaning

when worn at ritual ceremonies. By photographing these dancers in black and white,

at close range, I hope to reveal what is masked by the brilliant

color and acrobatic dance movements of powwow.

Jeffrey M. Thomas (Onondaga / Mohawk), *Amos Keye*, Iroquois Confederacy, 1983

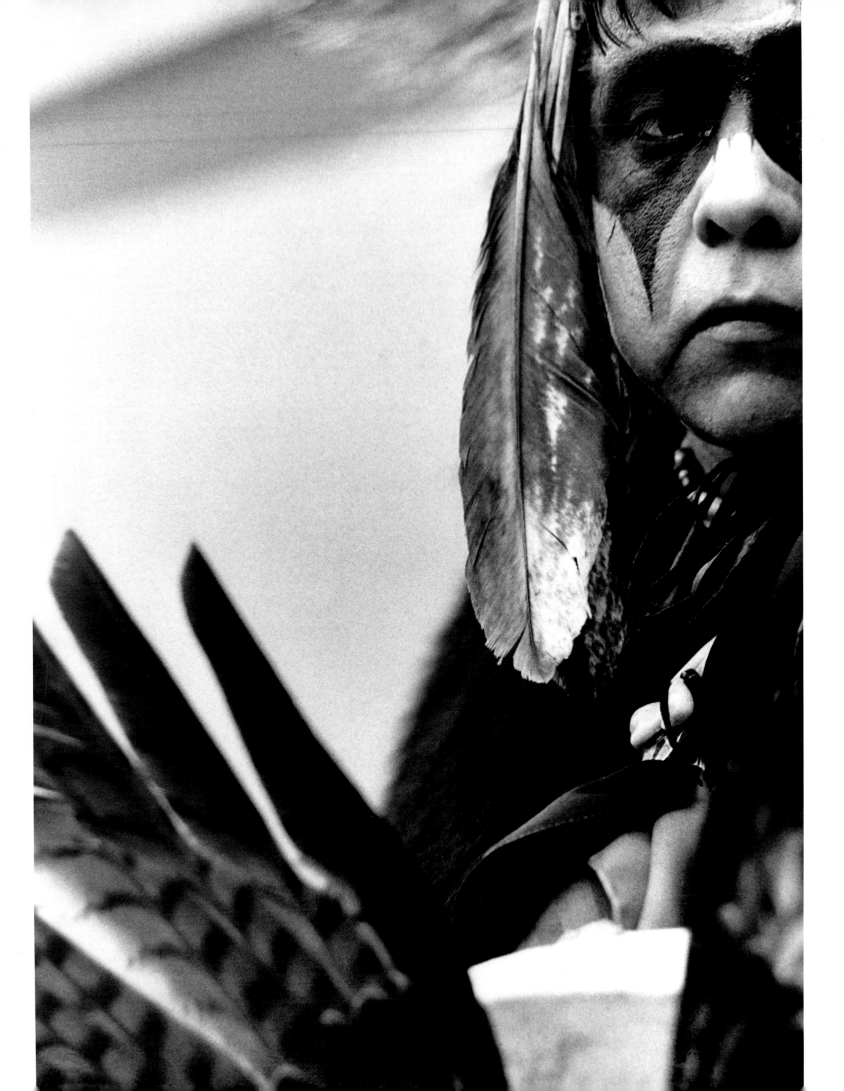

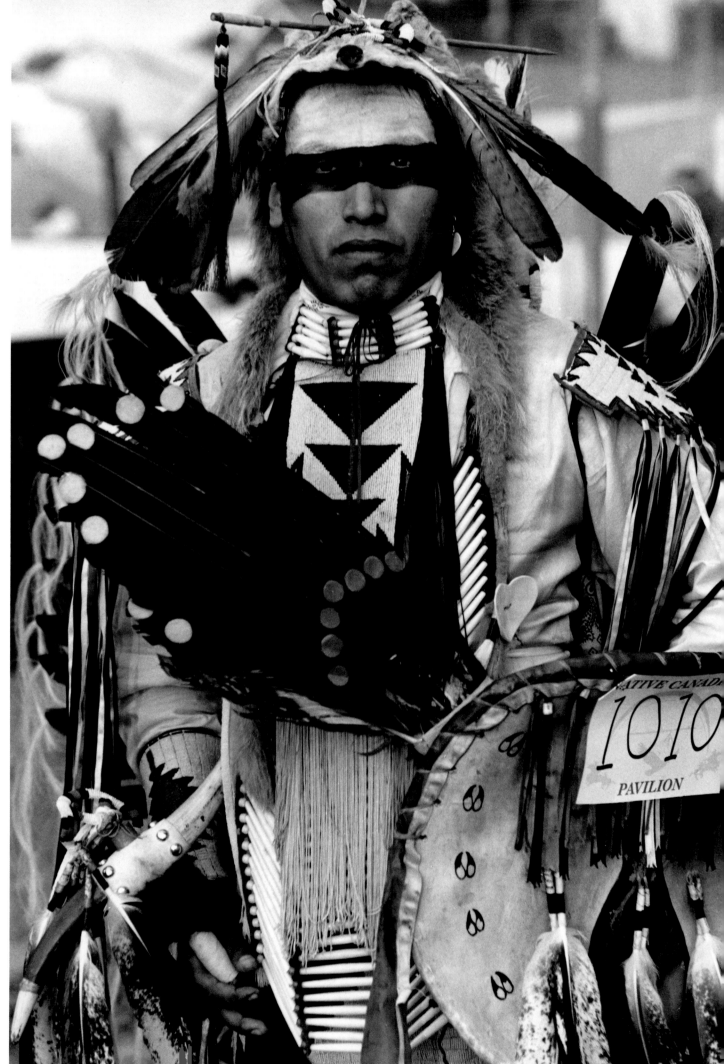

Pages 106-109:
Photographs by
Jeffrey M. Thomas

Right:
Gerald Cleveland,
Winnebago Nation,
1985

Opposite: Richard
Poafpybitty,
Applying Facial
Paint,
Comanche/Omaha
Nation, 1983

Page 108:
Detail of Dance
Bustle-Eagle
Head, Ojibway
Nation, 1983

Page 109:
Detail of
Breast Plate
and Arm Band
Niagara Falls,
New York, 1983

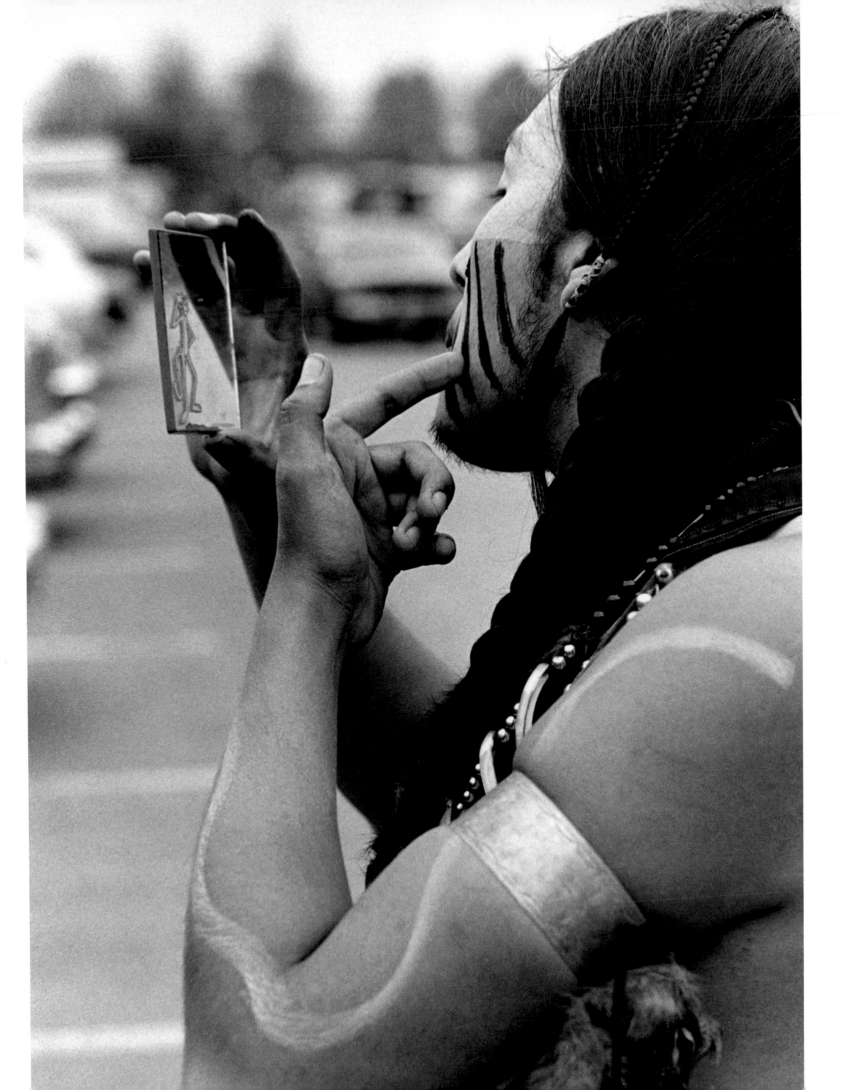

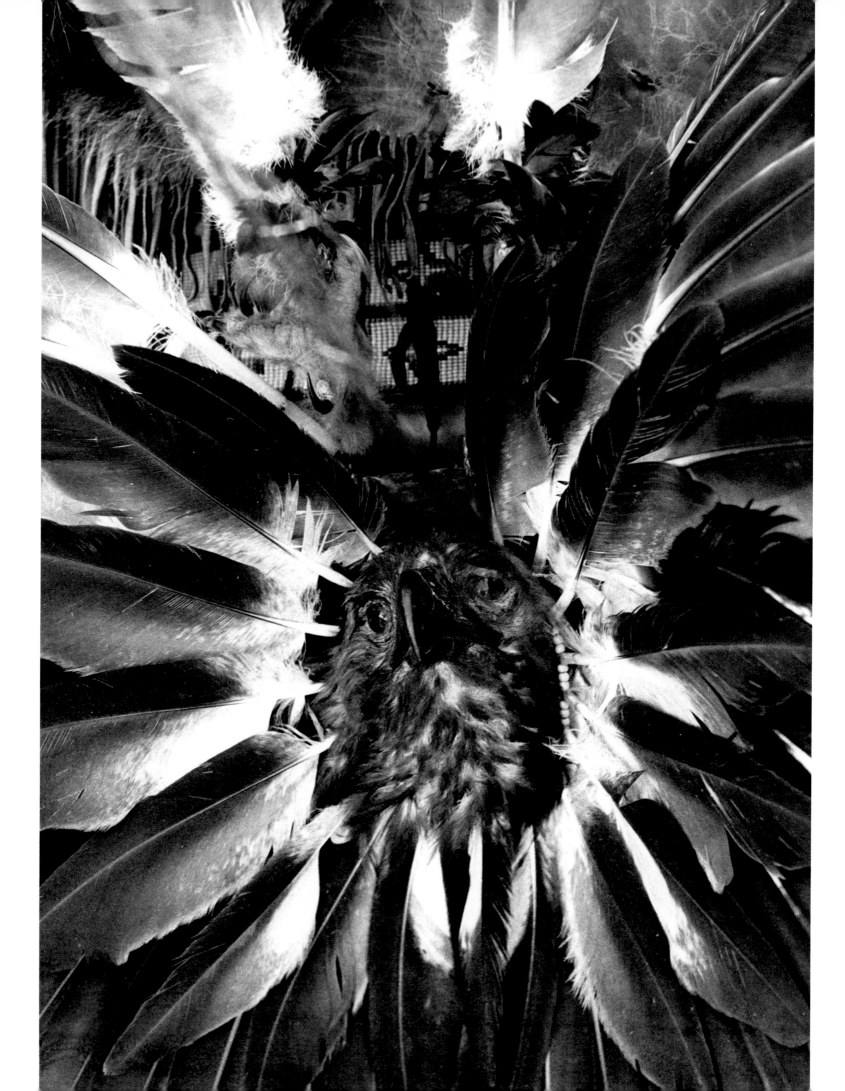

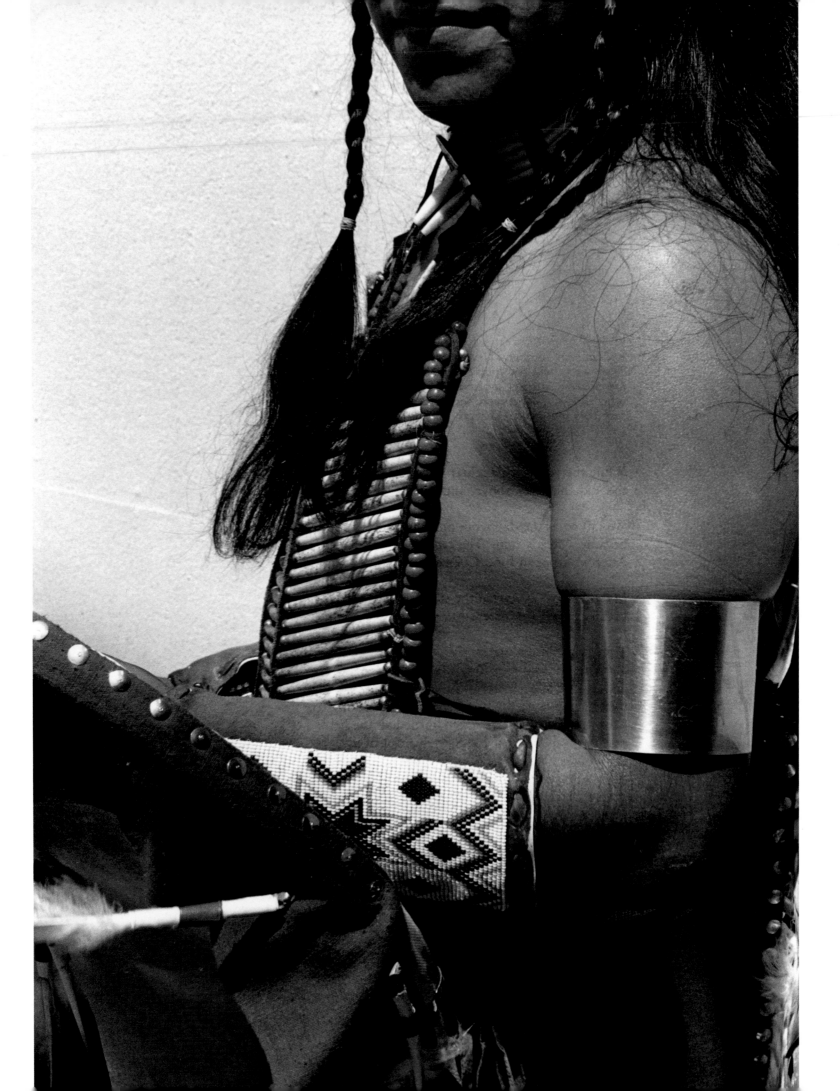

IN 1864

―――――

BY LUCI TAPAHONSO

In 1864, 8,354 Navajos were forced to walk from Dinetah to Bosque Redondo in southern New Mexico, a distance of three hundred miles. They were held for four years until the U.S. government declared the assimilation attempt a failure. More than 2,500 died of smallpox and other illnesses, depression, severe weather conditions, and starvation. The survivors returned to Dinetah[1] in June of 1868. . . .

While the younger daughter slept, she dreamt of mountains,
the wide blue sky above, and friends laughing.

We talked as the day wore on. The stories and highway beneath
became a steady hum. The center lines were a blurred guide. . . .
After we stopped for a Coke and chips, the storytelling resumed:

My aunt always started the story saying, "you are here
because of what happened to your great-grandmother long ago."

They began rounding up the people in the fall.
Some were lured into surrendering by offers of food, clothes,
and livestock. So many of us were starving and suffering
that year because the bilagaana[2] kept attacking us.
Kit Carson and his army had burned all the fields,
and they killed our sheep right in front of us.
We couldn't believe it. I covered my face and cried.
All my life, we had sheep. They were like our family.
It was then I knew our lives were in great danger.

We were all so afraid of that man, Redshirt[3], and his army.
Some people hid in the foothills of the Chuska Mountains
and in Canyon de Chelly. Our family talked it over,
and we decided to go to this place. What would our lives
be like without sheep, crops, and land? At least, we thought
we would be safe from gunfire and our family would not starve.

The journey began, and the soldiers were all around us.
All of us walked, some carried babies. Little children and the elderly
stayed in the middle of the group. We walked steadily each day,

stopping only when the soldiers wanted to eat or rest.
We talked among ourselves and cried quietly.
We didn't know how far it was or even where we were going.
All that was certain was that we were leaving Dinetah, our home.
As the days went by, we grew more tired, and soon,
the journey was difficult for all of us, even the military.
And it was they who thought all this up.

We had such a long distance to cover.
Some old people fell behind, and they wouldn't let us go back to help them.
It was the saddest thing to see—my heart hurts so to remember that.
Two women were near the time of the births of their babies,
and they had a hard time keeping up with the rest.
Some army men pulled them beside a huge rock, and we screamed out loud
when we heard the gunshots. The women didn't make a sound,
but we cried out loud for them and their babies.
I felt then that I would not live through everything.

When we crossed the Rio Grande, many people drowned.
We didn't know how to swim—there was hardly any water deep enough
to swim in at home. Some babies, children, and some of the older men
and women were swept away by the river current.
We must not ever forget their screams and the last we saw of them—
hands, a leg, or strands of hair floating.

There were many who died on the way to Hwééldi.[4] All the way
we told each other, "We will be strong as long as we are together."
I think that was what kept us alive. We believed in ourselves
and the old stories that the holy people had given us.
"This is why," she would say to us. "This is why we are here.
because our grandparents prayed and grieved for us."

The car hums steadily, and my daughter is crying softly.
Tears stream down her face. She cannot speak. Then I tell her that
it was at Bosque Redondo the people learned to use flour and now
fry bread is considered to be the "traditional" Navajo bread.
It was there that we acquired a deep appreciation for strong coffee.
The women began to make long, tiered calico skirts
and fine velvet shirts for the men. They decorated their dark velvet
blouses with silver dimes, nickels and quarters.
They had no use for money then.
It is always something to see—silver flashing in the sun
against dark velvet and black, black hair.

1. "Dinetah" means "Navaho country" or "homeland of the people."
2. "Bilagaana" is the Navajo word for Anglos.
3. Kit Carson's name was "Redshirt" in Navajo.
4. Hwééldi is the Navajo name for Fort Sumner.

Monty Roessel,
(Navaho)
*Memories of the
Long Walk*, Bosque
Redondo, New
Mexico, 1992

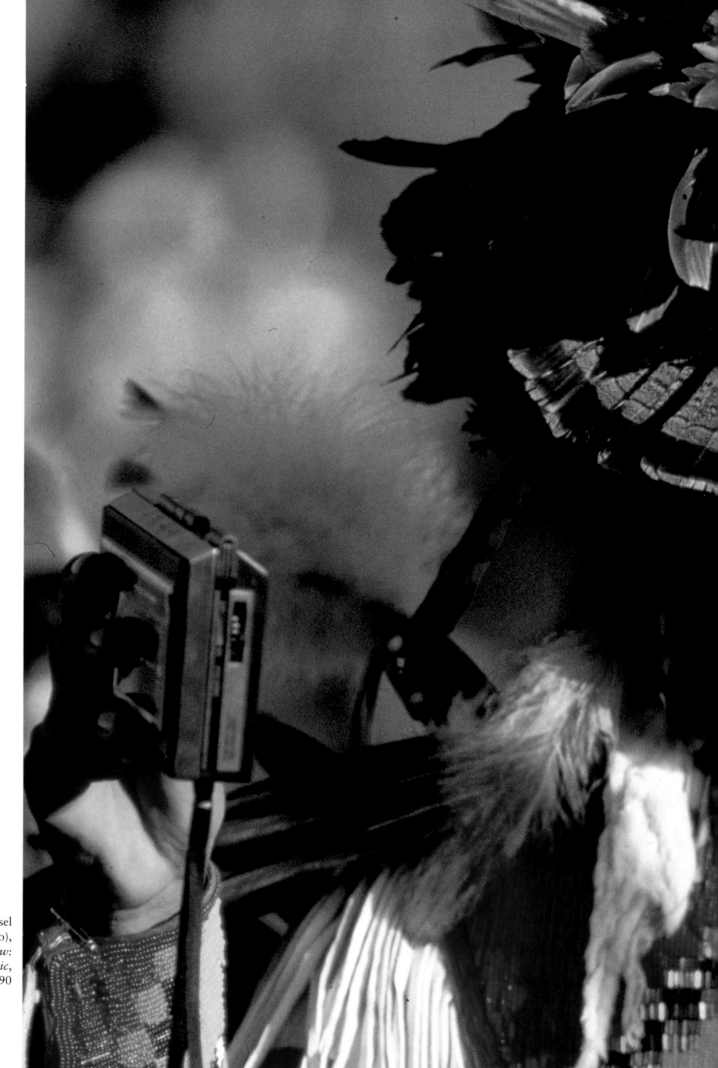

Monty Roessel
(Navajo),
*Powwow:
Recording Music,*
1990

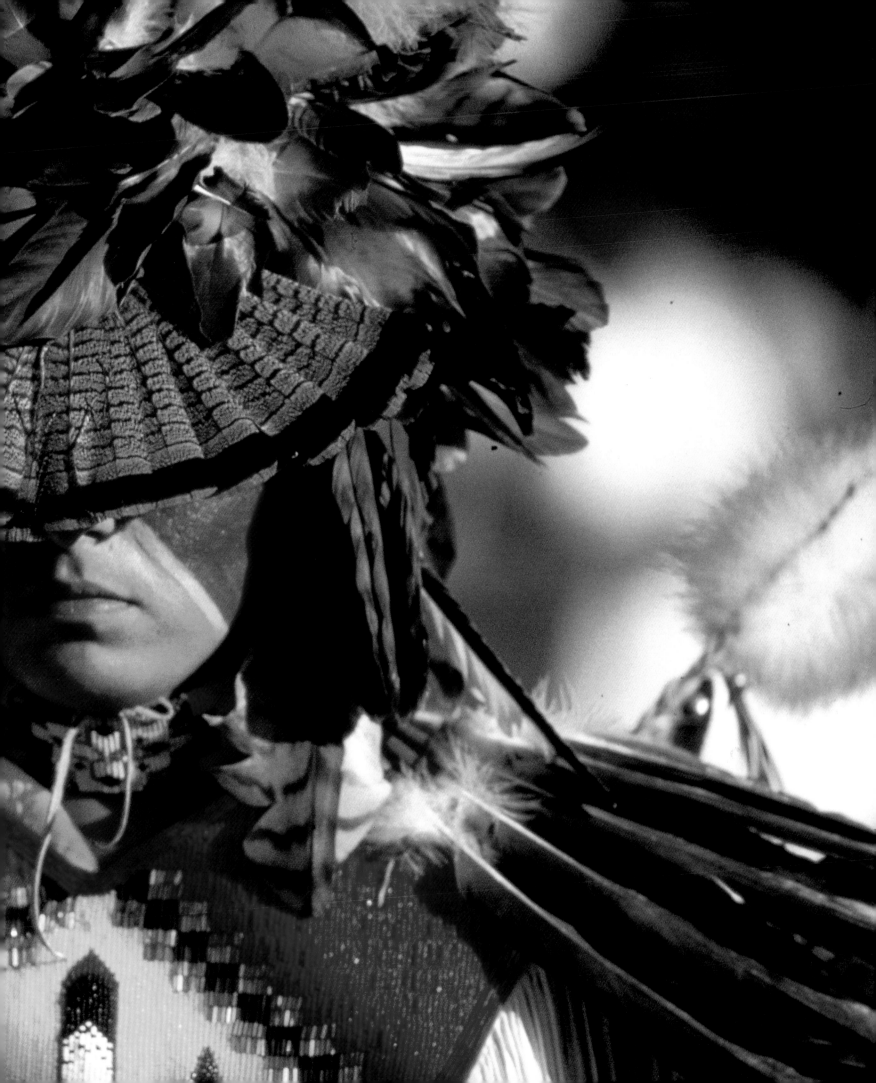

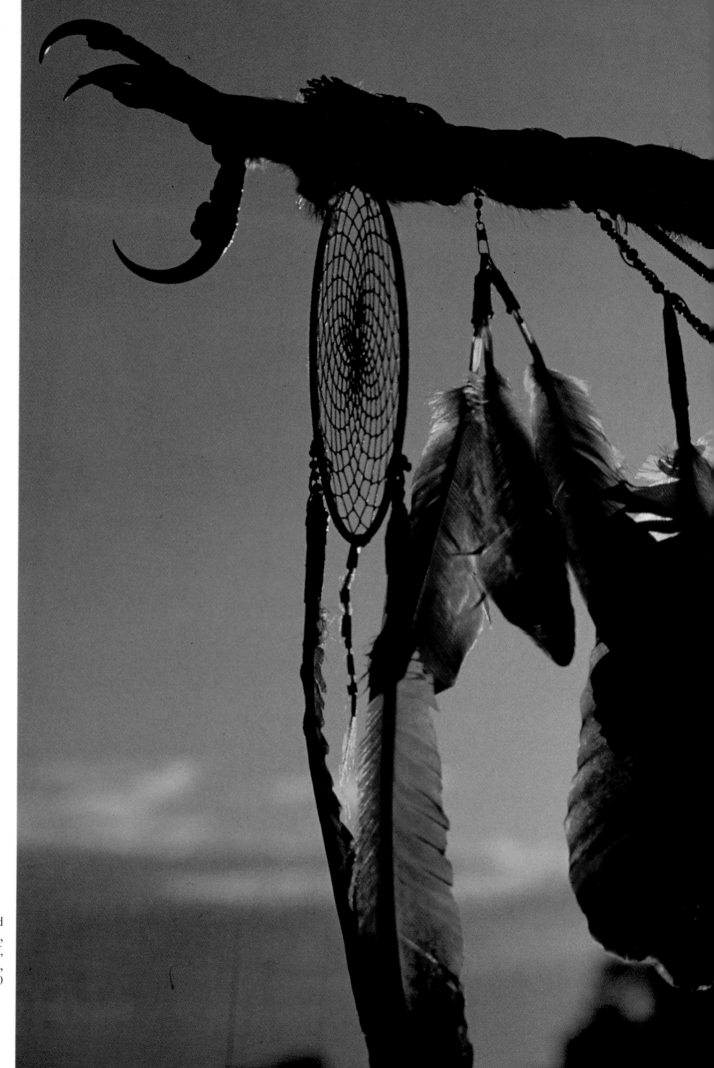

Ken Blackbird
(Assiniboine),
Eagle Staff,
Boise, Idaho,
1990

116

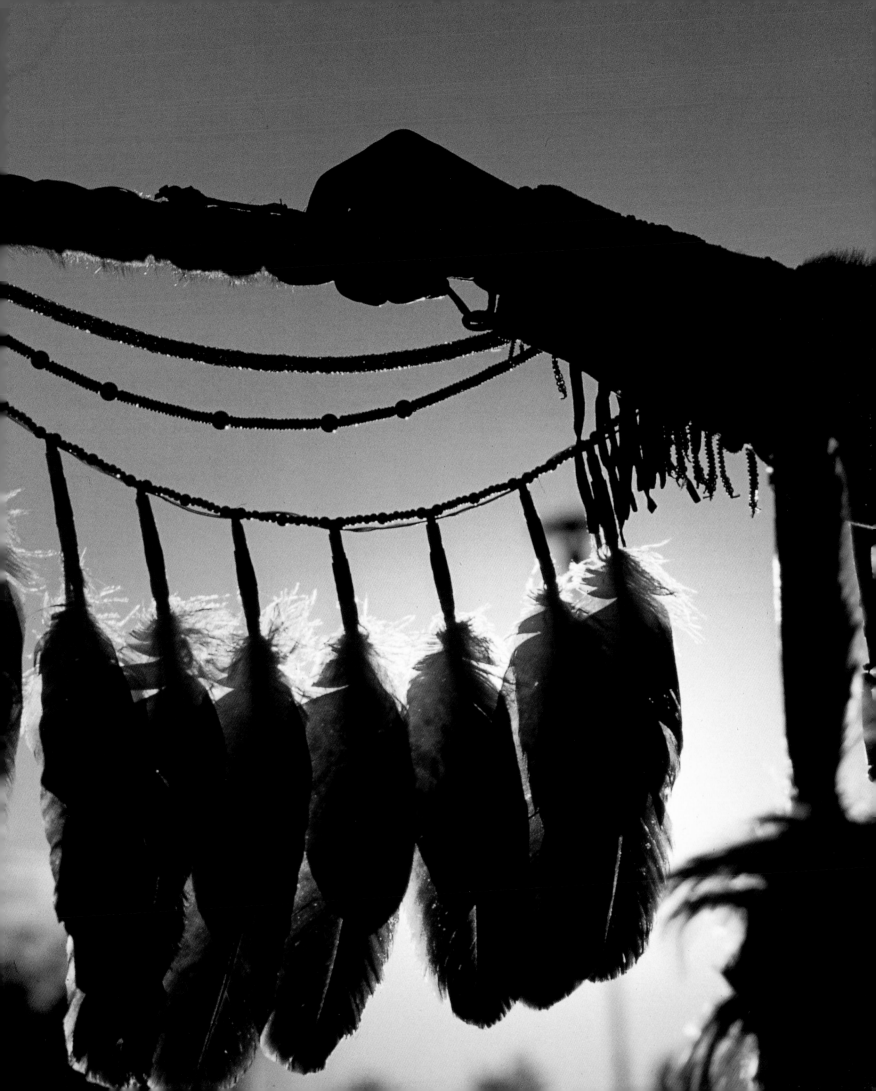

NANCY ACKERMAN (Mohawk ancestry) left her career as a field geologist to become a free-lance documentary photographer. She is a staff photographer for *The Montreal Gazette*, and is working on a long-term project portraying Native American women of North America.

WALTER BIGBEE (Comanche) studied photography at Rochester Institute of Technology. Recent assignments and commissions include work for the Smithsonian Institution Museum of the American Indian and the Smithsonian Institution Museum of Natural History, both in Washington, D.C.; Pathways Productions in Los Angeles; and Time/Life Books in Alexandria, Virginia.

KEN BLACKBIRD (Assiniboine) earned a degree in journalism at the University of Montana, but learned photography by people-watching, and reading history and the daily newspapers. He is currently a staff photographer at the *Anchorage Daily News* in Alaska.

RON CARRAHER (Colville Confederated Tribes) is Chairman of the Photography Program at the School of Art, and Professor of Art at the University of Washington. His work has been seen in many exhibitions, and is in the permanent collections of the Bureau of Indian Affairs and the Microsoft Corporation, among others.

PAMELA SHIELDS CARROLL (Blackfoot) holds degrees from California State College, San Francisco (B.A.) and Mills College (M.F.A.). In 1994, her work was included in the "Watchful Eyes" exhibit at the Heard Museum, and she was awarded a San Francisco Foundation Arts and Humanities fellowship.

JESSE COODAY (Tlingit/Woosh Keetaan Clan) was born in Ketchikan, Alaska, and now lives in New York City. His mixed-media works have been published in *The Photographer and the American Indian* (Princeton University Press, 1994); *The Native Americans* (Turner Publishing, 1993); and *Mixed Blessings,* by Lucy Lippard (Pantheon Books, 1990).

ROBERT DAVIS (Tlingit/Eagle Clan) is a poet and artist who lives in Kake, Alaska.

PATRICIA DEADMAN (Tuscarora) holds a B.F.A. from the University of Windsor, Ontario. She serves on the exhibition committee of the Native American/Inuit Photographers Association, and has exhibited in solo and group exhibitions throughout Ontario, and in the United States.

JOHN C. H. GRABILL began working in the Dakota Territory in 1886. His advertisements appeared and disappeared in newspapers during the late 1880s and early '90s, but little is known about this photographer, who signed his work, "Grabill Portrait and View Company, Deadwood, Dakota."

THERESA HARLAN (Laguna/Santo Domingo/Jemez Pueblo) is a graduate of the Ethnic Studies program at the University of California, Berkeley. As an independent curator, she has organized a number of exhibitions of Native American photography, including "Watchful Eyes" (Heard Museum, Phoenix, Arizona, 1994); "Through the Native Lens" (Southwest Association of American Indian Art, Santa Fe, New Mexico, 1993); and "Message Carriers" (traveling exhibition, 1992–93). Harlan is currently the curator of the C. N. Gorman Museum at the University of California, Davis.

LINDA HOGAN is the author of several books, including the poetry collections *The Book of Medicines* and *Savings*, and the novel *Mean Spirit*. Her work has been awarded grants from institutions such as the Guggenheim Foundation and the National Endowment for the Arts, and she has received the American Book Award. Hogan teaches creative writing at the University of Colorado.

ZIG JACKSON (Mandan/Hidatsat/Arikara) studied at Northeastern Oklahoma State University, the University of New Mexico, and received an M.F.A. from the San Francisco Art Institute. He currently holds a fellowship at the Headlands Center for the Arts, Sausalito, California. Jackson's work is in several public collections, including the Johnson Gallery, University of New Mexico; the Institute of American Indian Arts Museum, Santa Fe, New Mexico; and the Museum of Contemporary Photography, Chicago.

CARM LITTLE TURTLE (Apache/Tarahumara) studied at the University of New Mexico and College of the Redwoods. Her work has been widely exhibited throughout the United States, and is in permanent collections, including the Western Arts Americana Library, Princeton University; the Heard Museum, Phoenix; and the Southwest Museum, Los Angeles.

JAMES LUNA (Luiseño) is a film and video maker and performance artist. Luna teaches at Palomar College, San Marcos, California, and has been artist-in-residence at the Skowhegan School of Painting and Sculpture, and the University of California, Davis. Honors include the American Indian Motion Picture Award for *The History of the Luiseño People: La Jolla Reservation, Christmas 1990*, and a Rockefeller Foundation Intercultural Film/Video Fellowship.

LEE MARMON (Laguna) began his professional career in 1945. In 1994, he created a series of photo-murals for the Denver International Airport. His work has been exhibited throughout North America and has appeared in books and publications including the *Los Angeles Times*, *Newsweek*, *Time*, and *Southwest Art*. Marmon lives in Laguna Pueblo, New Mexico, where he owns and manages the Blue Eyed Indian Bookstore.

LARRY McNEIL (Tlingit/Nishgaa) is Professor of Photography at the Institute of American Indian Arts in Santa Fe, New Mexico, and is on the Board of Directors of the Native Indian/Inuit Photographers Association. His work is included in the permanent collections of Princeton University; the Heard Museum; the University of Alaska, Fairbanks; and the Angoon (Alaska) Heritage Center.

N. SCOTT MOMADAY (Kiowa) is the Regent Professor of English at the University of Arizona, Tucson. His first novel, *House Made of Dawn*, won a Pulitzer Prize. Nonfiction works include the autobiographical *Way to Rainy Mountain* and *The Names*.

DAVID NEEL (Kwagiutl) studied at the University of Kansas and Mount Royal College, Calgary. He received a Canada Council grant for his book, *Our Chiefs and Elders*, and his work is in the permanent collections of the National Museum of the American Indian, New York; the Seattle Art Museum; the National Archives of Canada; and the Canadian Museum of Civilization.

HORACE POOLAW (Kiowa, 1906–1984), was the first American Indian of his generation to be recognized as a professional photographer. After serving in the army, teaching aerial photography during World War II, he settled with his family in Anadarko, Oklahoma. There, he documented

the transitions in Kiowa culture within the wider context of postwar American culture.

JOLENE RICKARD (Tuscarora) is a photographer, educator, curator, and essayist on the subject of the representation of non-Western people. Her work has appeared in recent exhibitions including "Fire Without Gold" (Woodstock Photography Center, 1994); "Cracked Shell" (one-person show, Lightworks/Menshel Gallery, Syracuse University, 1994); "Partial Recall" (Tyler School of Art, Philadelphia, 1993); and "Decolonizing the Mind" (Center of Contemporary Art, Seattle 1992). Rickard teaches art and art history at University of Buffalo, New York.

MONTY ROESSEL (Navajo) earned a degree in journalism from the University of Northern Colorado and later studied with Robert Gilka (former director of photography, *National Geographic*). Roessel's work has appeared in *Geo, The New York Times Magazine, Newsweek, Time, Sports Illustrated*, and *Native Peoples*.

LESLIE MARMON SILKO (Laguna) is a poet and novelist. Her best-known novel, *Ceremony,* came out in 1977. Her work has been published in numerous magazines and collections, including *Writers of the Purple Sage*. She is the recipient of a five-year grant bestowed by the MacArthur Foundation.

PAUL CHAAT SMITH (Comanche) is a writer, curator, and cultural critic. During the 1970s, he worked with the Wounded Knee Legal Defense/Offense Committee and the American Indian Movement's International Indian Treaty Council. His recent essays have explored issues of representation, anarchy, photography, and punk music. His new book, *Like a Hurricane*, co-authored with Robert Allen Warrior, is a narrative account of the Indian movement for social justice, from the 1960s and 1970s, and will be published by The New Press in 1996. He currently lives in Washington, D. C.

GREG STAATS (Mohawk) has been a visiting lecturer at the University of Arizona, Tucson; the University of British Columbia; and the Nova Scotia College of Art and Design. Widely exhibited and published, Staats's work is in the permanent collections of the Canadian Museum of Civilization, Hull, Quebec; the Canadian Council Art Bank, Ottawa; and the Department of Indian and Northern Affairs, Ottawa.

MAGGIE STEBER (Cherokee ancestry) became the first woman picture editor at Associated Press Photos in 1973. Her work regularly appears in *National Geographic, The New York Times, Life*, and *Newsweek*. Recent awards include: the Overseas Press Club/Olivier Rebbot Award, Citation (1994) for photographic coverage in Haiti, and the Maine Photographic Workshop Photojournalism Award (1992).

LUCI TAPAHONSO (Navajo), born and raised in Shiprock, New Mexico, is an assistant professor of English at the University of Kansas, Lawrence. She has published four books of poetry: *One More Shiprock Night; Seasonal Women, A Breeze Swept Through*, and *The Women are Singing*. Her poetry has also been featured on national television and radio programs, including National Public Radio's "New Letters" series.

JEFFREY M. THOMAS (Onondaga/Mohawk) is a self-taught photographer who lives and works in Ottawa. His work is included in the permanent collections of Princeton University, the Museum of Civilization, the Southern Plains Indian Museum, and the Washington State Arts Council.

JAMES WELCH (Blackfeet/Gros Ventre) graduated from the University of Montana, and in 1969 he received a National Endowment for the Arts Fellowship in poetry. Welch's novels include *Winter in the Blood, The Death of Jim Loney, Fool's Crow, Indian Lawyer*, and *Killing Custer*. Welch received an American Book Award and the *The Los Angeles Times Book Prize* in 1986.

RICHARD RAY WHITMAN (Euchee/Creek) is a photographer and video artist, curator, lecturer, and cultural activist. His images have been exhibited at venues in North America and abroad, including the Studio Museum of Harlem and the New Museum of Contemporary Art, both in New York City; Impressions Gallery, York, England, and the Kulterheuse Museum in Stockholm.

ROBERT WILLARD, JR. (Tlingit/Eagle Clan) is the Executive Director of the Southeast Alaska Land Acquisition Coalition, which is seeking to amend the 1971 Alaska Native Claims Settlement Act. Willard, a former Alaska state trooper, has headed numerous public policy boards and commissions. He is an Eagle Clan elder, an oral historian, and co-chairman of the Constitutional Committee of the Tlingit and Haida Indian Tribes of Alaska.

CREDITS

Unless otherwise noted, all photographs are courtesy of, and copyright by, the artists. Sizes refer to exhibition format, with height listed first: p. 4 courtesy the Royal Anthropological Institute of Great Britain and Ireland, London; p. 6 Colt Patent Firearms Manufacturing Company advertisement courtesy the Museum of Connecticut History, Hartford, Connecticut; p. 8 photograph by John C. H. Grabill courtesy the Library of Congress, Washington, D.C.; p. 10 photograph courtesy the University Archives, John Vaughn Library, Northeastern State University, Talequah, Oklahoma; pp. 12–18 all photographs by Horace Poolaw courtesy the Horace Poolaw Photography Collection, Stanford University, Stanford, California; p. 19 photographs by Winnie Poolaw courtesy the Horace Poolaw Photography Collection, Stanford University, Stanford, California; pp. 42–49 all photographs courtesy Shooting Back, Minneapolis, Minnesota; p. 50 mixed media, 20 x 15" by George Longfish, private collection, San Francisco; p. 52 mixed media, 20 x 30" by George Longfish; p. 56 liquid light on muslin 44 1/2 x 32 1/2" by Pamela Shields Carroll, courtesy private collector, San Francisco; pp. 69–72 hand-colored sepia-toned prints by Carm Little Turtle from the series "She Wished for a Husband, Two Horses, and Many Cows," courtesy the Heard Museum, Albuquerque, New Mexico; p. 73 hand-colored sepia-toned prints by Carm Little Turtle, courtesy the Copeland Rutherford Gallery, Santa Fe, New Mexico.

ACKNOWLEDGMENTS

There are many people who helped to make *Strong Hearts* possible. For bringing an impressive array of artists to our attention, we are grateful to Jesse Cooday of New York City; Larry McNeil of Santa Fe, New Mexico; the Native Indian/Inuit Photographers' Association of Hamilton, Ontario; Yvonne Maracle, Director. For his generosity in providing prints of Horace Poolaw's work, we thank Dr. Charles Junkerman of the Stanford Humanities Center, Stanford University. For their efforts we also extend thanks to Richard Pearce Moses of the Heard Museum, Phoenix, Arizona; Jillian Slonim of the American Federation of Arts, New York City; Atlatl, Phoenix, Arizona; and the American Indian Community House, New York City.

WE DIDN'T JUST CREATE A CAMERA, WE CREATED A WHOLE NEW CLASS.

The Carl Zeiss T* Hologon 16mm f8.0 provides 106 degrees angle of view with extremely low residual distortion.

The Carl Zeiss G Series lens collection includes a Carl Zeiss T* Sonnar 90mm lens (a fantastic portrait lens).

Select the sophisticated elements from an SLR and add them to the essence of a compact camera...the result is the Contax G1. The G1 is more than a camera, it's a camera system that provides all the elements of control and precision expected from a Contax camera in a small, extremely versatile package.

The G1 system has four newly designed, interchangeable Carl Zeiss T* lenses including: the AF Biogon 28mm f2.8, AF Planar 45mm f2.0, AF Sonnar 90mm f2.8 and Hologon 16mm f8.0. These lenses make up the finest series of Carl Zeiss lenses ever. Additionally, your current T* SLR lenses can be used on the G1 with the GA-1 Mount Adapter.

The new, compact G1 lenses are designed to provide the highest contrast and resolution along with the lowest distortion obtainable. Since the G1 does not require a mirror box or pentaprism, lens designers had more freedom to design for higher optical performance. Further, since there is no mirror, vibration and noise are reduced to unbelievably low levels.

The viewfinder of the G1 zooms to match the installed lens and corrects automatically for parallax and focal distance. Also, coupled to the viewfinder is a +3D to -2D diopter, selectable by the user for easy use without eyeglasses.

The G1 has an advanced passive autofocus system with an extended base length, which is critical to enhanced accuracy compared with conventional compact cameras. Along with AF focusing, the G1 also has a manual focus system to preserve the ability of the photographer to choose.

Automatic Bracketing Control (A.B.C.) is built-in on the G1 and provides an automatic three frame continuous (over/right on/under) exposure system. Further control is possible via the exposure compensation system allowing exposure changes of +2EV to -2EV in 1/3 step increments. A Custom Function system is also built-in on the G1 to allow the photographer to customize various elements of camera performance.

The shutter is a focal plane vertical travel composite material providing lightweight and precision quartz timed shutter speeds. The shutter speed range on the G1 is from 1/2000 second to 16 seconds in automatic AE mode (1/2000 sec. to 1 sec. in manual mode).

Through The Lens (TTL) flash metering is standard on the G1, allowing perfectly exposed flash photographs every time with the new Contax TLA140 flash or other Contax TLA flashes.

Light, strong and beautiful, titanium covers the rugged copper/silumin steam annealed chassis of the G1.

Controls on the G1 are very simple, clear and extremely quick to operate.

Accessories abound in the new Contax G1 system, including filters, lens shades, power packs, accessory strap, deluxe leather system carrying cases, and a special Mount Adapter called the GA-1. It allows the Carl Zeiss T* SLR lenses to be used with the G1.

The Contax G1 is a state-of-the-art camera system that evokes the traditional qualities of Contax while pushing the limits of creative design into the 21st century.

CONTAX G1
The Essence of Carl Zeiss T* Optics